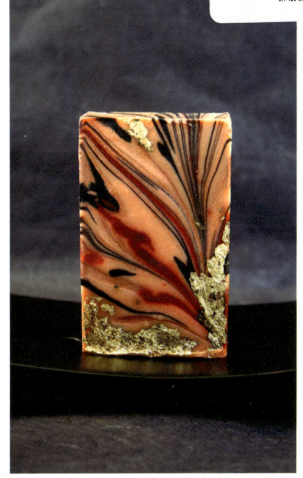

The Art of Soap

Edited by Debbie Chialtas

Photography by Erin Pikor

Foreword by Robert Mahar

Published by Soapylove©

Copyrights to the features belong to the individual contributors.

Photography copyright © 2010 Soapylove.

Except for photographs on pages 57 - 60 which are © Erin Pikor

All rights reserved. No part of this book may be reproduced in any form without written permission from the publisher.

ISBN 978-0-615-39778-8

Printed in the United States of America

First Edition

First Printing 2010

Inquiries should be made to Debbie Chialtas at:

Soapylove
10419 La Morada Dr.
San Diego, California 92124
hello@soapylove.com

www.artofsoap.com

Special thanks go to

The Handcrafted Soap Maker's Guild

for their generous support of this book

and all they do to both promote and educate

the hand crafted soap community.

www.soapguild.org

This book is dedicated to my

late grandmother, Florence McNulty,

who will always be my favorite soap maker.

9

Philosophy

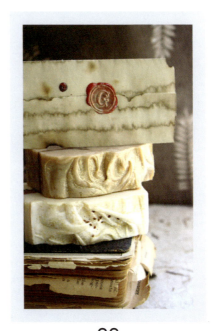

33

Inspiration

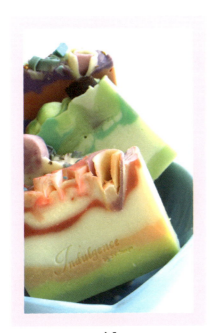

61

Technique

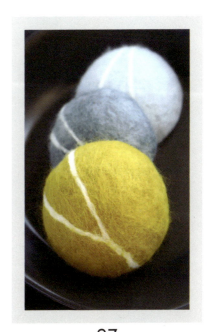

87

Presentation

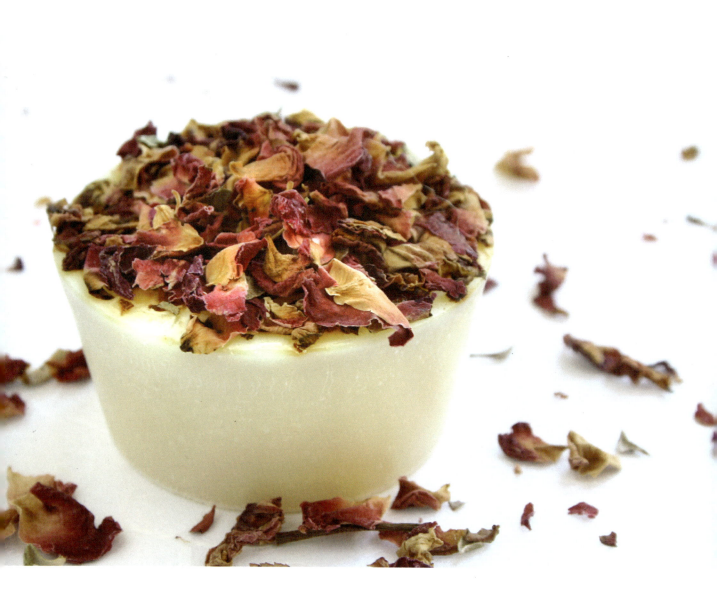

Foreword

Soap as art? Academics have long waged a dusty debate over the question of what distinguishes art from craft. The most obvious distinction often lies in the matter of utility. Fine art such as painting and sculpture arguably serves to provide inspiration, beauty, social and political commentary – all rather abstract and conceptual characteristics. Craft may also embody many of the same aspirations but also serves to address a tangible need – woodworking produces a chair to sit in, pottery provides a bowl to eat from.

Where things get more interesting, at least in my mind, is when artists and artisans 'color outside the lines' and create work that extends beyond the traditional confines of their medium. A glass blower forgoes making stemware and vases to pursue a career creating sculptural installations. Conversely, a painter strays from brush and canvas to design a line of textiles for your bed linens and clothing. Each of these forays to 'the other side' causes that line between art and craft to become more and more faint.

What you'll find in *The Art of Soap* are 24 soap makers (individuals and collectives) who have embraced both art and craft with such passion and enthusiasm as to bring them one step closer to being inseparable. Whether compelled by issues of health and well being, personal loss or joy, devotion to faith, or love of nature, their soap making practices are significantly elevating the aesthetic of their soapy medium and improving its utilitarian purpose of cleansing the skin.

Visually, you've never seen soap like this before and without a little coaching you might not know that some of these were soap at all. Some masquerade as gorgeous crystalline rocks, frosting topped baked goods, and petri dishes straight from the laboratory. Others draw design inspiration from marbled Italian papers, references to great works of art, and the Zen beauty of simple shapes and forms.

Enjoy this soap themed trip around the globe and be certain to follow up with visits to the respective soap artist's web sites for more information and to purchase their work.

- *Robert Mahar*

After a 13 year career as an appraiser of Modern and Contemporary art in Los Angeles, Robert Mahar launched the highly curated online emporium MaharDrygoods.com in 2005, featuring vintage and artisan crafted curiosities for children. He also serves as Grand Poobah of the JuniorSociety.com clubhouse, his weekday blog on better than average kiddy culture and design.

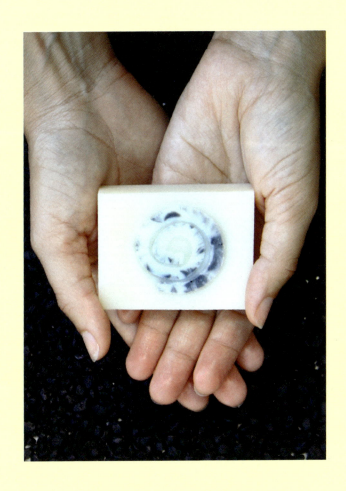

Philosophy

Michele Stapley

Zigwicks

Sydney, Australia

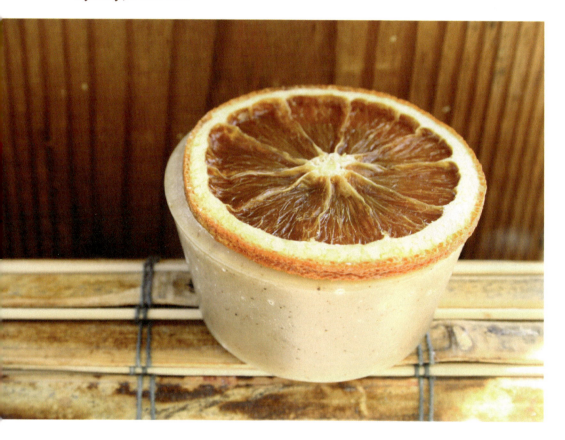

"The bush has an intrinsic beauty which is very much a part of my soap making creativity."

Philosophy

Hello! My name is Michele Stapley and I am the artist behind Zigwicks handmade soap. My original inspiration for making handmade soap was the birth of my beautiful son Ziggy, and the need to find a pure and natural way to care for his brand new skin. Forever unhappy with the commercial detergents available on supermarket shelves, I decided it was time to do something about it, and Zigwicks was born.

I've always enjoyed creating everything from scratch, so all of my soaps are made using the cold process. Using this method allows me the freedom to create simple, natural and unique soaps that can be used by everyone, including those with sensitive skin. Zigwicks soaps are primarily made using olive, coconut, and rice bran oil and are beautifully scented using pure essential oils.

Most of my artistic inspirations come from the Australian bush and all that it has to offer. Whether it be the striking fragrance of the lemon myrtle, the therapeutic benefits of Australian Tea Tree, or the handsome brute that is the Australian gum nut, the bush has an intrinsic beauty which is very much a part of my soap making creativity.

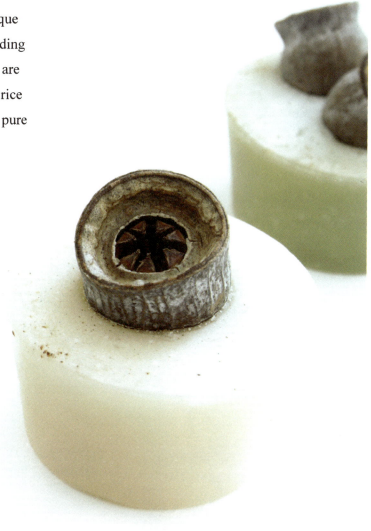

Philosophy

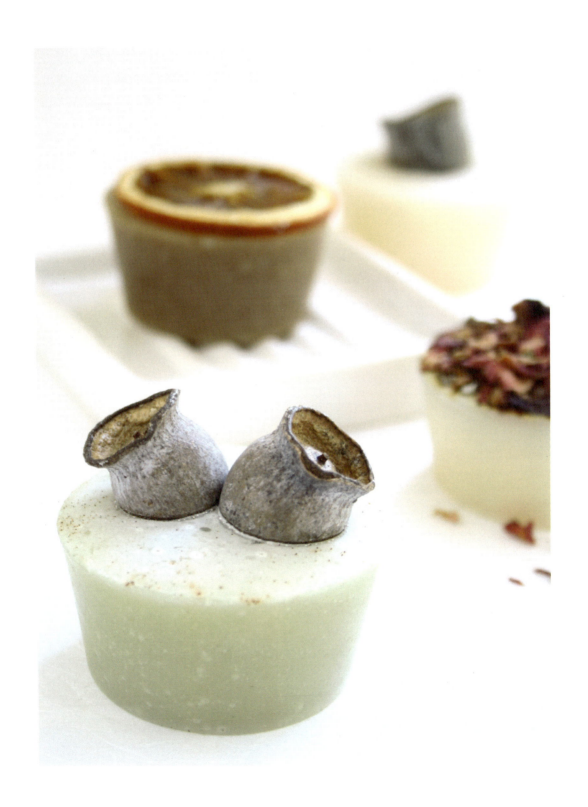

Philosophy

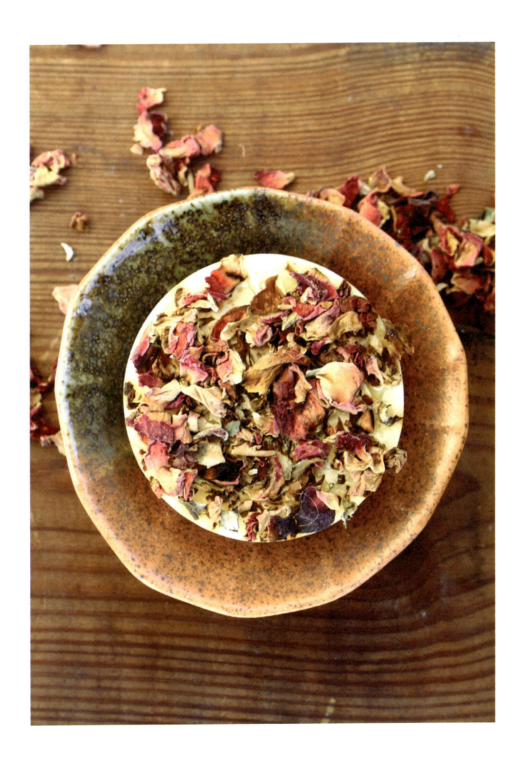

Yuichi Iida

Brown Rice Family

Brooklyn, New York, USA

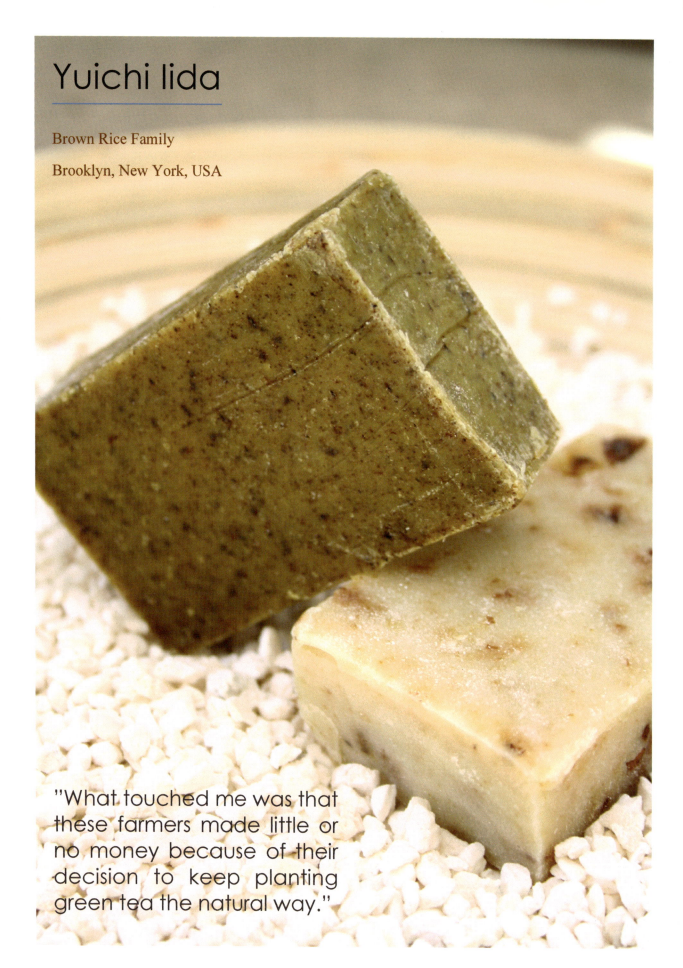

"What touched me was that these farmers made little or no money because of their decision to keep planting green tea the natural way."

Philosophy

Brown Rice Family was started four years ago by me, Yuichi, and another friend of mine from Korea, Joe Jang. It started out as a band with just the both of us, Joe played the guitar and sang while I played the Djembe. I was very much into healthy living, eating, planting, culture and being Eco friendly, I became a vegetarian a few years back and introduced Joe to this kind of life style. We decided that our music would represent this, spreading positive vibes and love to the community.

We started doing some heavy research on making soap without the use of chemicals, without testing on animals and using nothing but organic and natural ingredients. We made our first batch and handed samples to our friends. They loved the soap and asked if we had more. Joe and I saw this as an opportunity that could grow into a business. We decided to go deeper into our research and soap making. Our goal was to make the best quality soap with natural ingredients that are good for the skin. Soap is a product that reaches a wide range of people. No matter what race, age, or culture, almost everyone uses soap to wash their skin.

My hometown, Shizuoka, a small city in Japan, is a place best known for its green tea, clean water and good soil. I learned that green tea was good for skin and I had an idea about adding green tea to our soap. I decided to pay a visit to my home town and learn more about green tea and how it is grown.

I visited a green tea farm where the tea is grown without the use of chemicals or any kind of technology. They sustained the old ways of farming, hand picking the insects from the leaves, using natural soil and clean water, and carefully harvesting the green tea leaves. What touched me was that these farmers made little or no money because of their decision to keep planting green tea the natural way. I decided that all my green tea used to make my soap would come from these farmers from Shizouka.

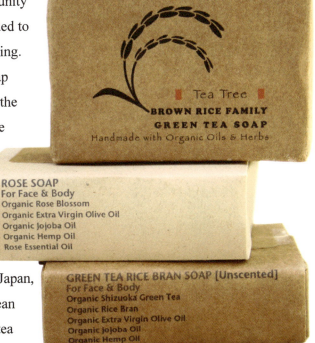

Philosophy

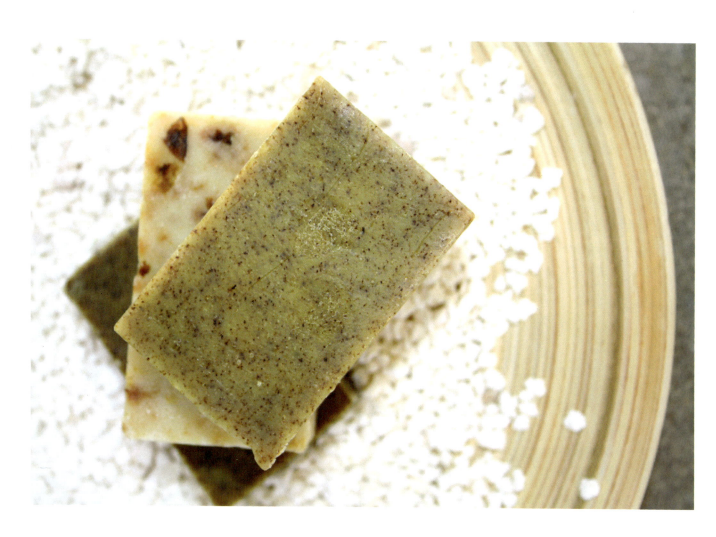

Philosophy

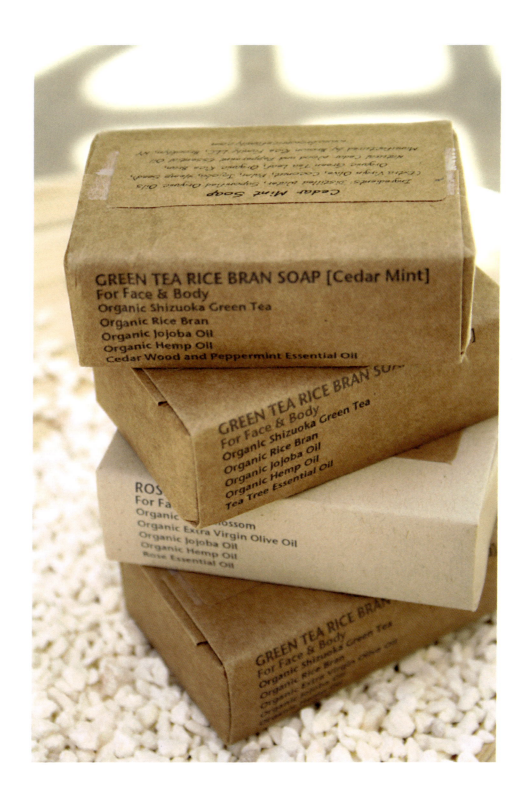

Janet Kang

A*Kang's

Kaohsiung, Taiwan City, Taiwan

"The colors from the soaps are like poems which elegantly combine together."

Philosophy

In 2002 I met an Italian who promoted environmental protection. He made soaps and natural skin care products, and lived a pure natural life. This simple yet natural living style had been something I longed for, so I started my own journey of making handmade soap.

I try not to use colorants which contain chemicals. Those pigments are always eye catching but I love natural plants or sludge more because they create softer colors. When I started making soap I found that those materials brought me gentle and more comfortable feelings on my skin when I use them.

The colors from the soaps are like poems which elegantly combine together. I love natural soap colors, but it's always a difficult task to make them appear the way I want them to. I have learned from my mistakes.

I have found another canvas by making handmade soap whose fats, essential oils, water, plants, and seeds all come from mother earth. I'm so happy that I can touch nature's gift with my own hands, and with this handmade soap I can feel all natural atmospheres.

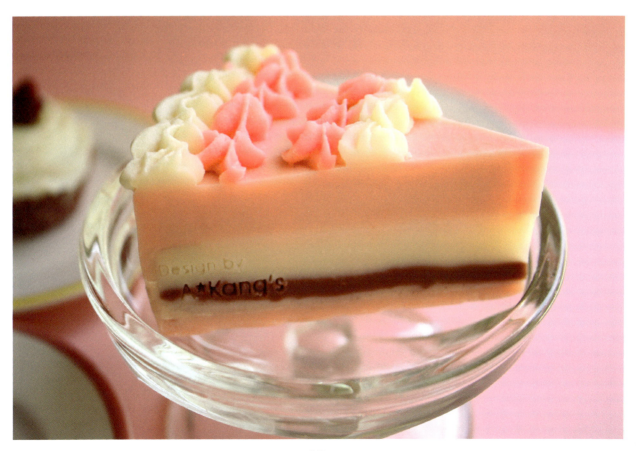

Philosophy

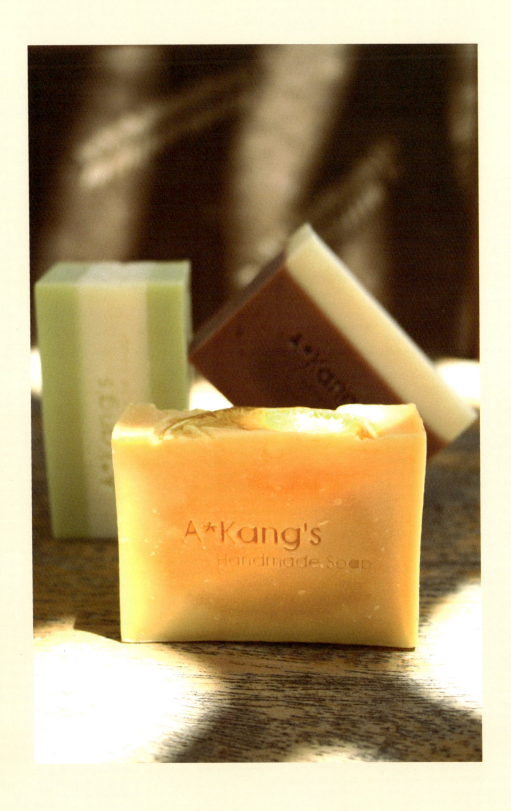

Philosophy

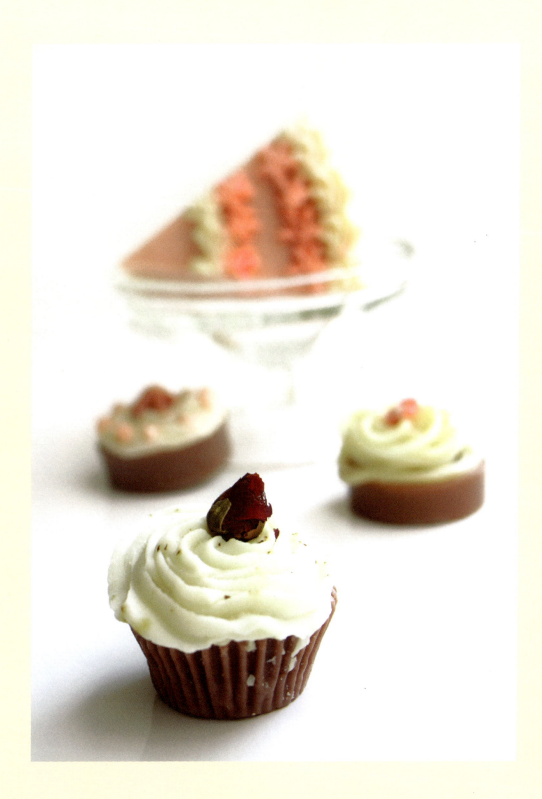

Freda Lau

Dapan

Toronto, Ontario, Canada

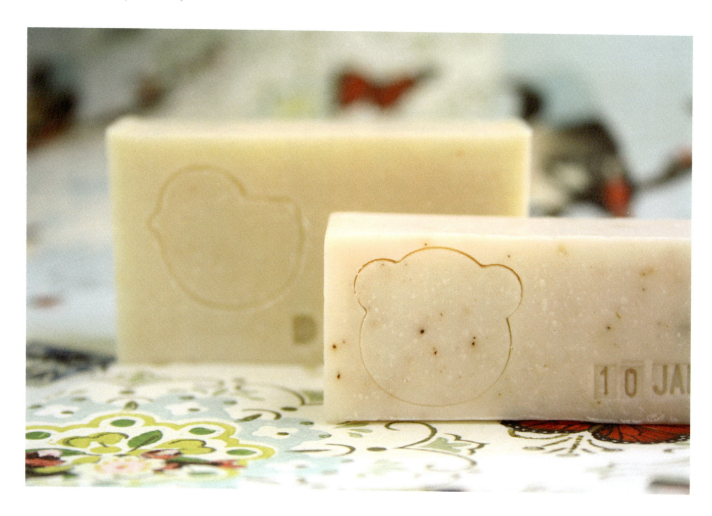

"I believe simple is beautiful."

Philosophy

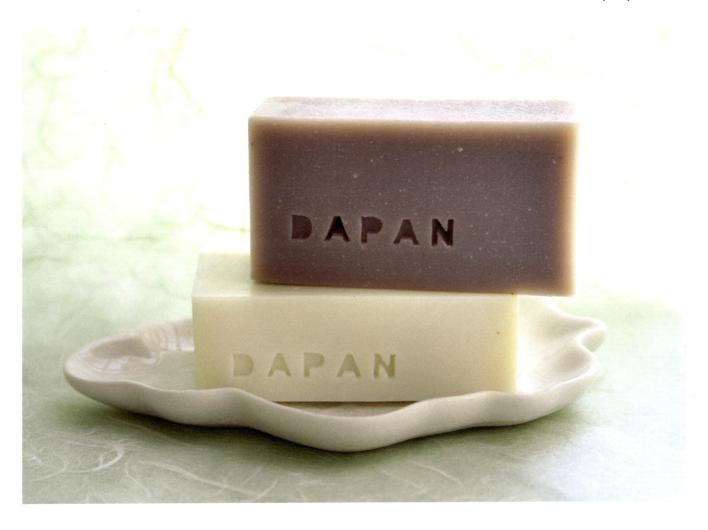

Why do I love soap making? Perhaps I should talk about what I do… Cooking is my hobby and I'm a freelance food photographer. I like food and enjoy trying different flavors. I create my own recipes to make healthy dishes for my family, then I garnish the dishes and take photos to remember what I had enjoyed. One day I decided to expand my passion from food to soap making. What excites me is that creating a soap recipe is similar to creating a cooking recipe.

Ginger is one of my favorite cooking ingredients and commonly used in the Chinese culture. It can cure nausea and help with digestion. In soap it can stimulate circulation in the skin. I have also been exploring different varieties of Chinese herbs, such as He Shou Wu, which in Chinese traditional medicine is believed to be among the best herbs to prevent premature graying of hair and hair loss.

When it comes to photo modeling and packaging, I believe simple is beautiful.

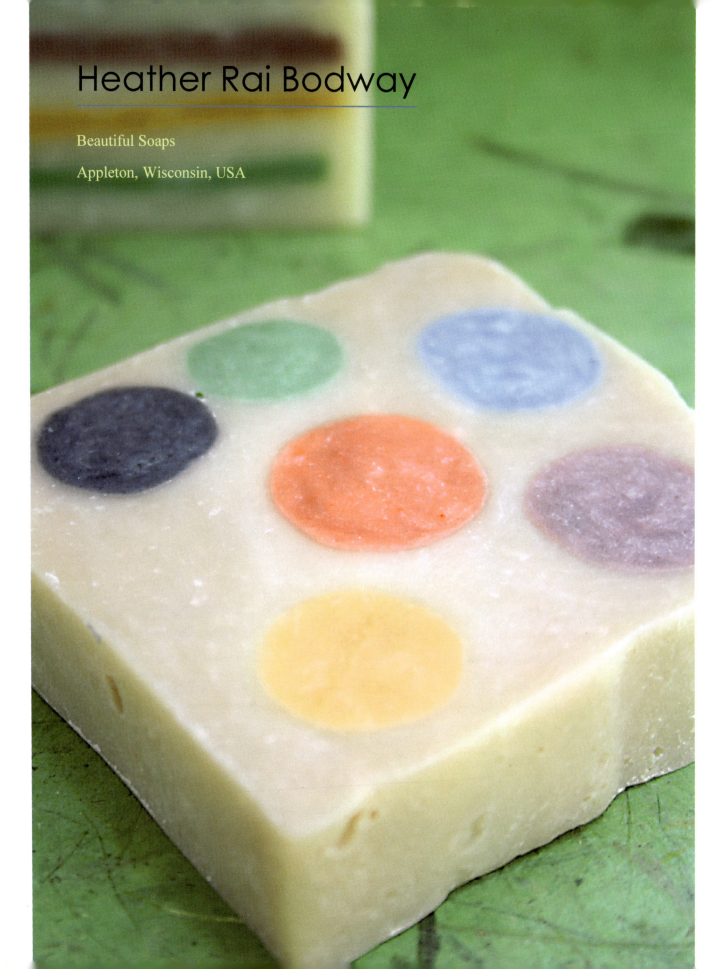

Heather Rai Bodway

Beautiful Soaps

Appleton, Wisconsin, USA

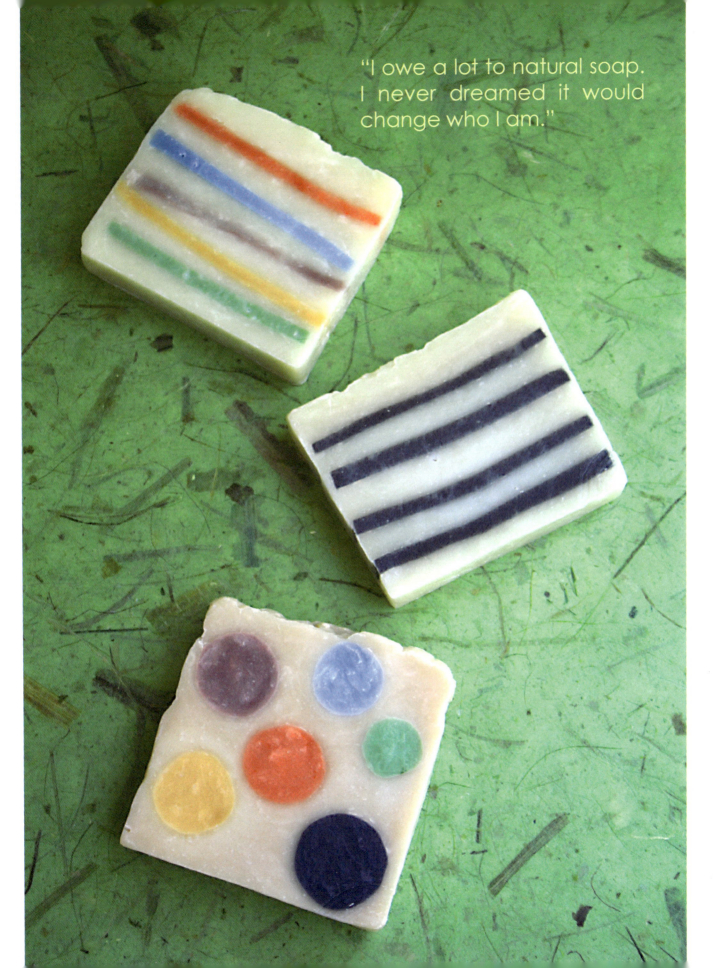

"I owe a lot to natural soap. I never dreamed it would change who I am."

Philosophy

I'm Heather Rai. I've been making soap for about two years now. My inspiration came when I decided I wanted to smell like a stick of incense that I liked. I searched high and low but couldn't find any "opium" scented soaps. In my pursuit, a friend introduced me to Nag Champa soap. I couldn't believe how amazing my skin felt and how great I smelled. I was hooked.

I'm a crafter by nature, so after spending a small fortune on handmade soap I decided that I could create my own. I researched day and night, reading everything I could and watching video after video. I did everything to the letter. After about a month of being fearful of lye, I finally got the nerve up to make my first batch.

It was Opium Poppy Seed, and it actually turned out! An addiction was born.

I've been making soap a couple times a week since my first batch. I was worried in the beginning that I would run out of ideas but it's like cooking - you never run out of recipes or modifications, you just keep getting better. Sometimes I lay awake at night thinking of new soap recipes. I've learned to write things down.

I make many different soap styles . My favorite are pure, natural bars made with essential oils and clays. My wild side loves to create polka dots, stripes, layers and confetti chunks! I used to work with polymer clay logs and have drawn

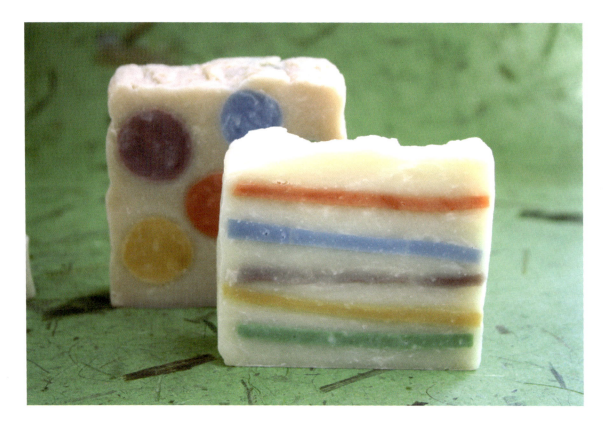

Philosophy

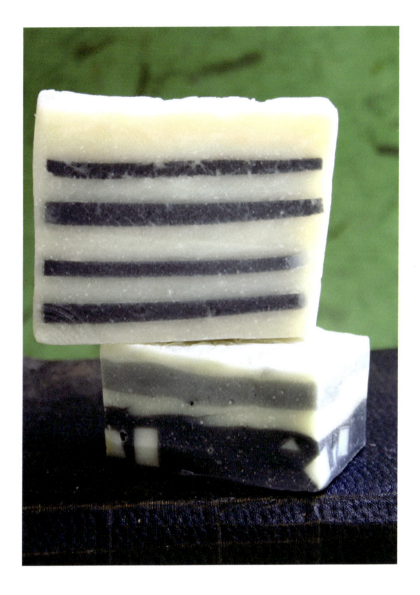

a lot of that art into my patterned soap. I embed contrasting and complimenting shapes right into my soap loaves. Once you've cut them, there it is: a beautiful and sometimes surprising new pattern.

Soap making has brought me so much joy. It has really changed the way I look at life altogether. I'm much more conscious of chemicals, detergent fillers, and parabens. I also look at handmade items with such love and admiration now. I appreciate the human touch and each minor imperfection tells its own story. It has increased my knowledge of herbs and natural remedies and even changed the way I eat. I owe a lot to natural soap, I never dreamed it would change who I am.

Maggie Wang

Toronto, Ontario, Canada

"The first question is often the same one, 'Why animal fats?' My answer has never changed, 'Why not?'"

Philosophy

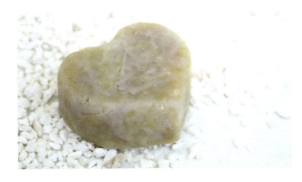

The first question I get when people hear about my animal fat ingredients is often the same one, "Why animal fats?" My answer has never changed, "Why not?" When I make soaps I want to give my family and friends a clean and natural alternative to off-the-shelves products, and animal fats are just as natural as olive oil and shea butter. They also make great bars of soap!

I began making soaps when my husband's co-worker lost his wife to cancer. That's when I realized how many harmful chemicals go into our daily cleaning products. I then began my quest for all-natural soaps. I'm always hunting for natural ingredients, scents, and colorants. I guess that explains why I was able to overcome my initial "yuk!" about animal fats.

Using animal fats has led me to friends that chose to breast feed. Some lucky mothers are blessed with abundant breast milk but have problems feeding it all to their babies. They asked me to use their milk to make soaps. I had my fair share of doubts when they approached me, but I was eventually surprised by the creaminess and gentleness of the soaps. One thing I learned from making breast milk soaps, is never turn your back on a new ingredient until you've tried the soaps!

What I enjoy the most about soap making, in addition to the planning, the revealing, and the smile you see on loved ones' faces, is the mixing process. I used to take out my stick blender to fast-track this stage, but now that I've discovered the joy and the rewarding feeling when I slowly bring the mixture to trace, I know that I'm adding a little bit more love with each stroke I mix in. Love is without a doubt my favorite natural ingredient I put into my soaps.

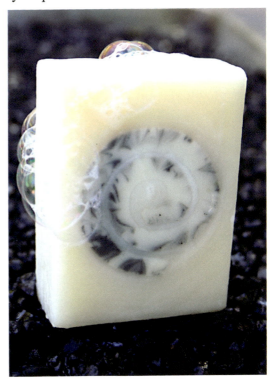

Philosophy

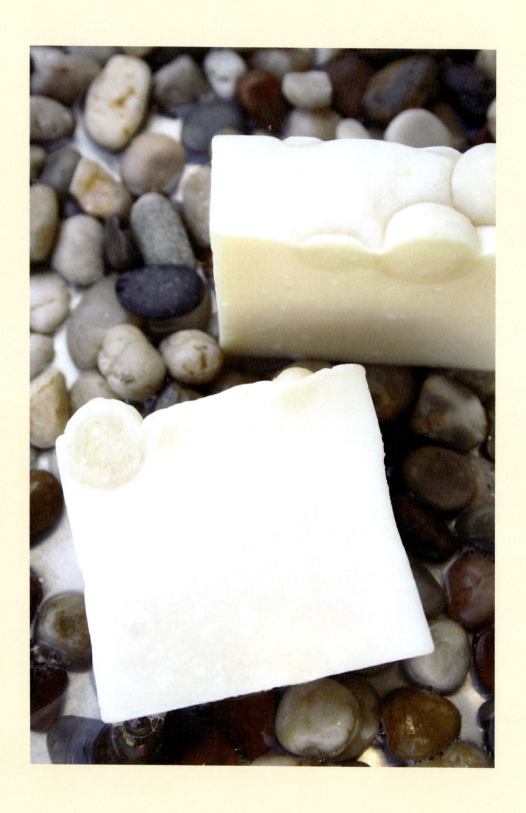

Philosophy

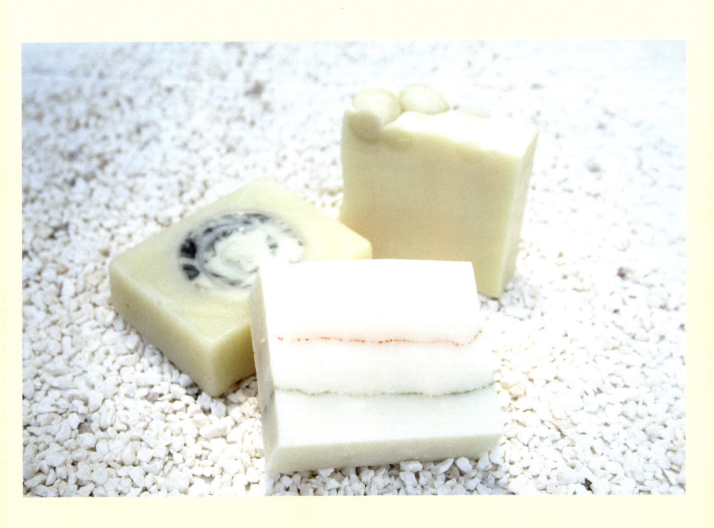

Philosophy Artisan Web Sites

Michele Stapley of Zigwicks

www.zigwicks.com

Yuichi Iida of Brown Rice Family

www.brownricefamily.com

Janet Kang of A*Kang's

www.akang.tw

Freda Lau of Dapan

www.idapan.blogspot.com

Heather Rai Bodway of Beautiful Soaps

www.artfire.com/users/HeatherRai

Maggie Wang

www.betweenfriends.blogspot.com

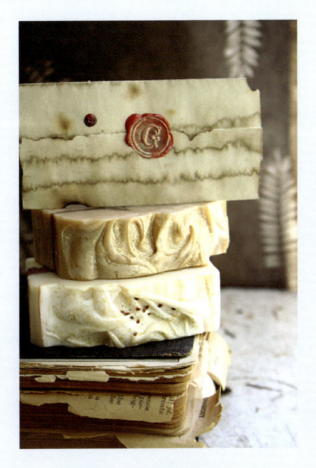

Inspiration

Sister Cathleen Marie Timberlake

Monastery Scents

Clyde, Missouri, USA

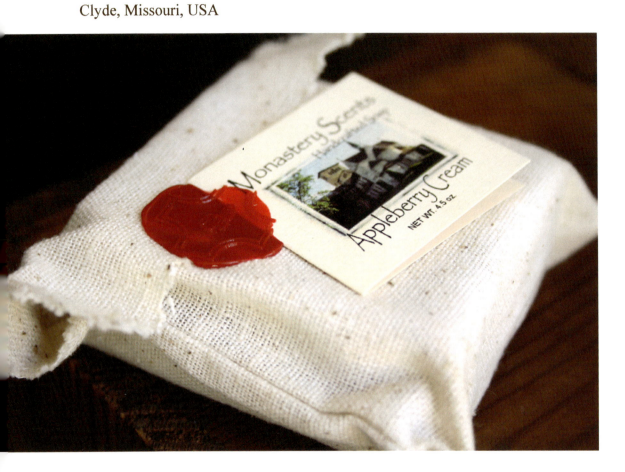

"I decided to add a few drops of holy water to each batch as a concrete way to add my blessings and prayer."

Inspiration

Long before I ever became a soap maker I became a Benedictine Sister of Perpetual Adoration. In other words, I am a Catholic nun. My community is somewhat unusual in that we do not have jobs most people associate with sisters or nuns. We are not teachers, nurses, social workers. We do not run soup kitchens or hospitals. Our work is prayer.

We live together in a large monastery set in the rolling hills of rural Missouri. We come together five times a day to pray. We also take time to pray privately and hold before God the needs of the world.

While we do not work outside the monastery, we surely do plenty of work within it! Our main source of income is the production of altar breads – the small round wafers that are used at Mass and in communion services in many Christian churches. Our sisters manage the production and business aspects of the altar bread department.

While our lives are structured around our times of prayer and work schedules, we seek to live a balanced life. We are encouraged to cultivate hobbies and recreational activities within the monastery setting.

In 2000, I received a bar of homemade soap as a gift. I was intrigued by it and thought, "I can do this." I have always enjoyed working with my hands and so I looked up a recipe on the Internet, procured my ingredients, found a small broom closet for my use, and began making soap!

Initially, I made soap just for our sisters' use. Gradually, I refined my techniques; I went from cold process to hot process. The sisters appreciated the soap and so I decided to sew some simple muslin bags and gave a few as gifts. They were very well received and that encouraged me to expand. What began as a hobby slowly became a small hand crafted soap business called Monastery Scents.

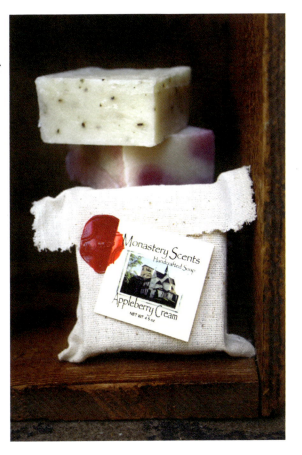

Inspiration

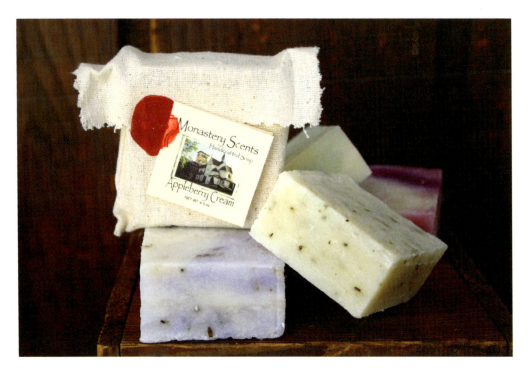

Because prayer is such an integral part of my life, I would pray as I made the soap. I prayed for the people who would use it – that it might bring them hope, joy, healing – whatever graces they most needed.

Somewhere along the way, I decided to add a few drops of holy water to each batch as a concrete way to add my blessings and prayer. At first I didn't tell anyone that I did, thinking it wouldn't matter to people. I can't remember how it happened that someone found out but they did and those who bought the soap were even more thrilled with it.

As I have met other soap makers and vendors, they seem surprised to find out that I am a nun and make soap. For me, it just seems like such a natural expression of our life. In the early days of the monastery, the sisters made their own soap. The Rule of Saint Benedict, which we follow, says "When they live by the work of their hands, then they are truly monks." So, I feel that my soap making carries a rich heritage. It continues both the tradition in our community of making soap and the Benedictine tradition of supporting ourselves by the work of our hands.

My simple hobby has become so much more than that. I am happy to say that I enjoy it as much today as I did when I began. I still thrill at the whole process of making and packaging the soap. I also enjoy the public outreach and marketing aspects of the soap business as it gives me a chance to share with people who

Inspiration

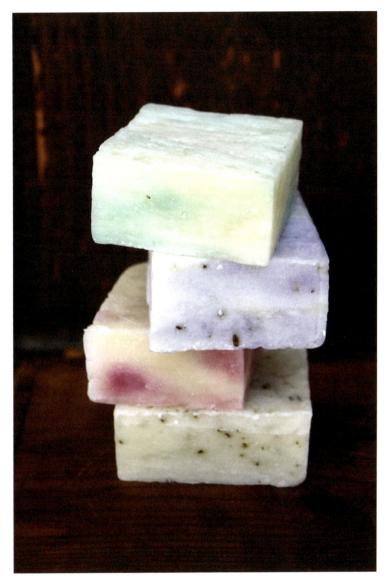

otherwise may not have heard of my community.

I have been humbled by the emails and words of gratitude I have received. I have heard from soldiers in Iraq who were touched by the prayers that accompany each bar of soap, from a family who used my soap to wash the body of a dying loved one, and from a new mom who insisted my lotions be with her in the hospital as she gave birth.

While I have put a lot of hard work and time and effort into Monastery Scents, I can only give credit and thanks to God who, as it says in Psalm 90, "blessed and prospered the work of my hands."

Sharon Jenkins

Morgan Street

Bridgeport, Connecticut, USA

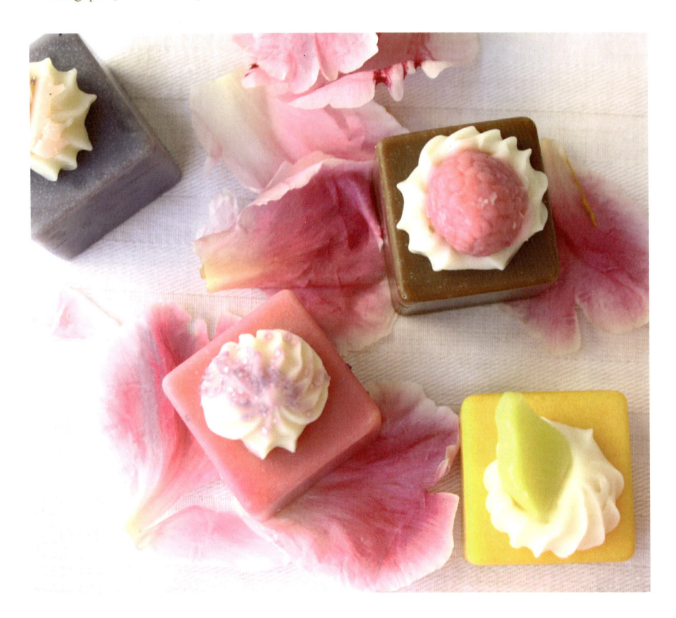

"Making soap is what makes my heart smile, gives me the warm fuzzies, makes everything right with the world."

Inspiration

I'm Sharon and I'm addicted to soap - it's as basic as that. Making soap is what makes my heart smile, gives me the warm fuzzies, makes everything right with the world. I'm mostly inspired by food (namely desserts). Unlike most people, whenever I walk by a bakery or cake shop, I stop to admire the delectable looking desserts not only because I'd like to that I was going to make something so she could enjoy bath time too. At the time I wasn't sure what I was going to make - soap, cream, lotion or what. I came across the book "The Soapmaker's Companion" by Susan Miller Cavitch and studied it for at least 6 months before making my first batch of soap. And so the madness began.

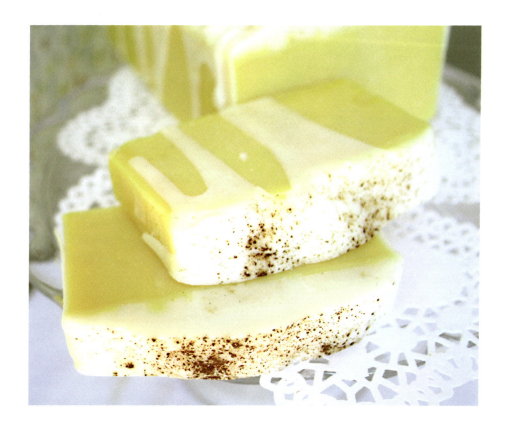

devour them all, but because I'm imagining how to recreate them using soap.

It all started about 10 years ago when my very young niece had such a terrible case of eczema she was unable to take regular bubble baths like her siblings. I felt so bad for her I told my sister

My soap making process today has changed quite a bit from 10 years ago. When I first started I followed the book instructions to the tee, down to calculating my lye solution with pen and paper, until I felt comfortable enough to start experimenting on my own.

Inspiration

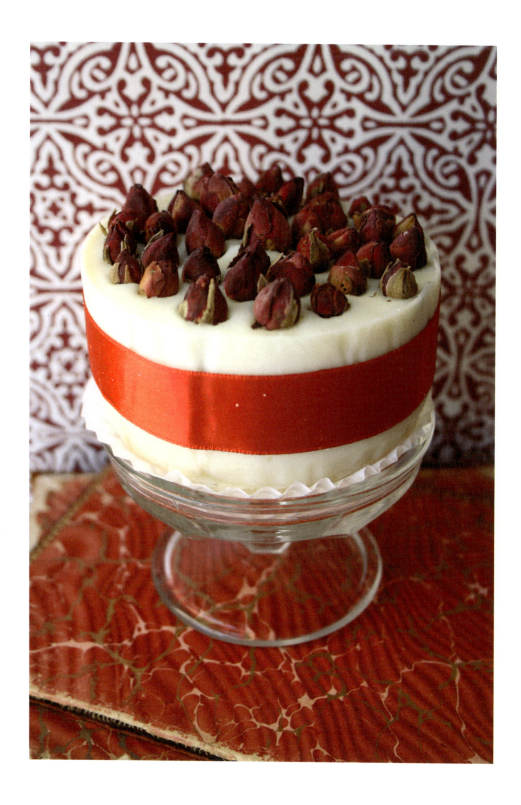

Inspiration

Back then I worked in a silo. I had no idea there were other people out there doing what I was doing or that there were online soap making communities where people shared their knowledge with each other. Imagine my surprise when I made that discovery? A whole new soapy world opened up before me and best of all, I discovered the online lye calculator. What more could one ask for?

A typical soap making session for me begins with a yearning for the scent of raw soap. I absolutely LOVE that smell. Raw liquid soap, right before you color or scent it or pour it into its mold. I think this is what heaven will smell like. At this point I clear the kitchen of all 2 or 4 legged animals, pull out the equipment, gather ingredients, roll up my sleeves and sometimes a quick crack of the knuckles is in order.

I usually don't decide on a color or scent until I'm half way through the soap making process (unless of course I'm making a restock batch). I've been known to wait until the very last moment to make my decision and have on a few occasions almost lost the little window of opportunity and ended up with plain unscented soap. Is that what they call living on the edge? Yeah, that's me!

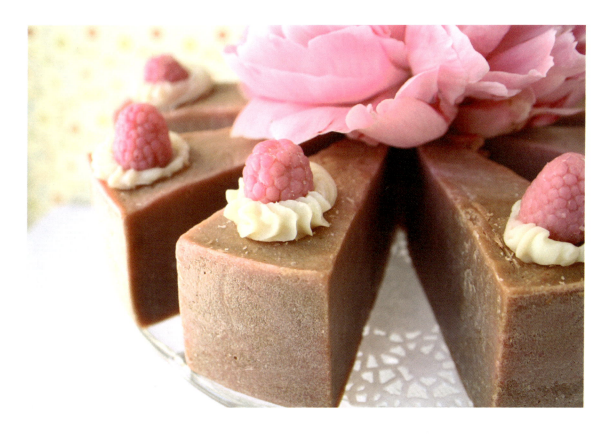

Britton Boyd

Haus of Gloi

Portland, Oregon, USA

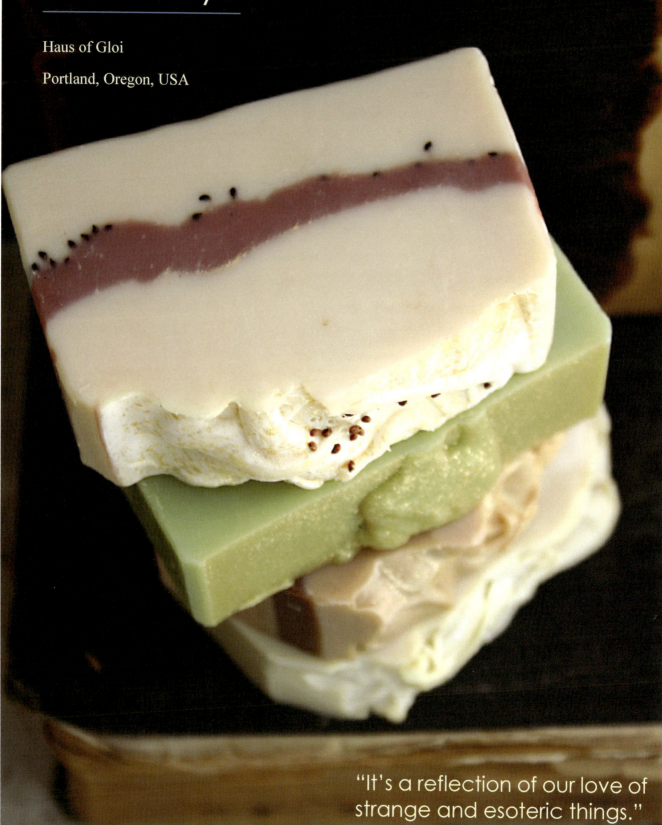

"It's a reflection of our love of strange and esoteric things."

Inspiration

I became hooked on handmade soap after I tried my first bar about three years ago. I eventually hit the library in search of soaping information and surprisingly, they had a lot of books on the subject! I spent tons of money and time being a hobby soaper before I took the plunge and started selling on Etsy. Thankfully I married a graphic designer. Matt takes care of all the design work while I work on production, fragrances, and new products.

When I'm developing new scents or looking for ideas, I usually turn to mythology and old text, or something that may have my current interest. I'm also inspired by documentaries. I recently saw one on Japanese "Satoyama" villages (they live in harmony with nature) that got me very inspired. I also have a top secret cookbook that pairs up flavors for all kinds of foods, herbs and spices, so whenever I'm in a block or am looking for an idea, I usually find myself there. I used to cook professionally as well so I draw from my culinary skills when developing soaps and products. Scent ideas come to me from everywhere.

Naming soaps and fragrances is an interesting process - Matt helps me. Sometimes we get an idea immediately and sometimes it will tease us for days. We try to pick names that fit in with the rest of our scents. A lot of customers remark that we have a "dark" theme - I think it's a reflection of our love of strange and esoteric things and the unique way that we get to express that adoration.

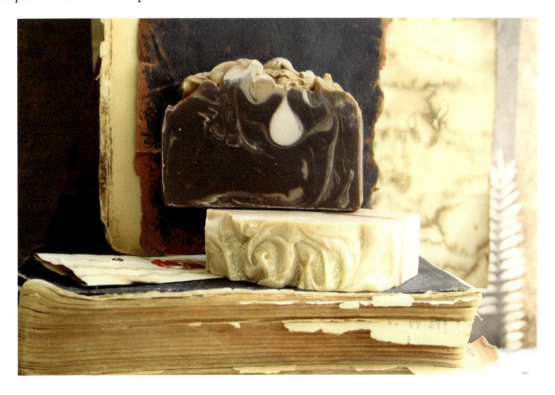

Inspiration

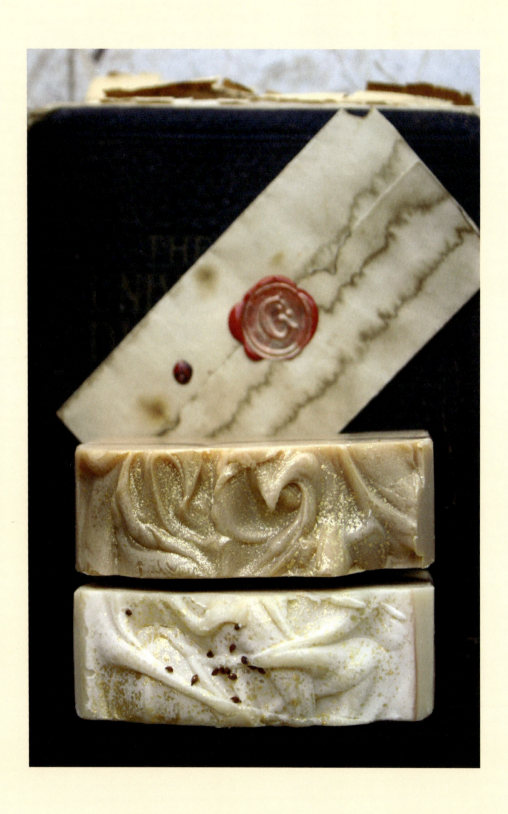

Inspiration

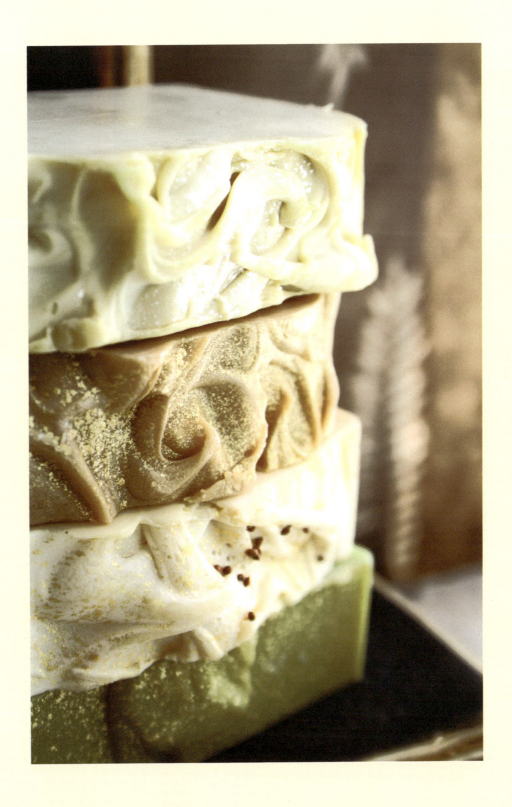

Estermann Karine

Ka Fée

Montmorency, Val d'Oise, France

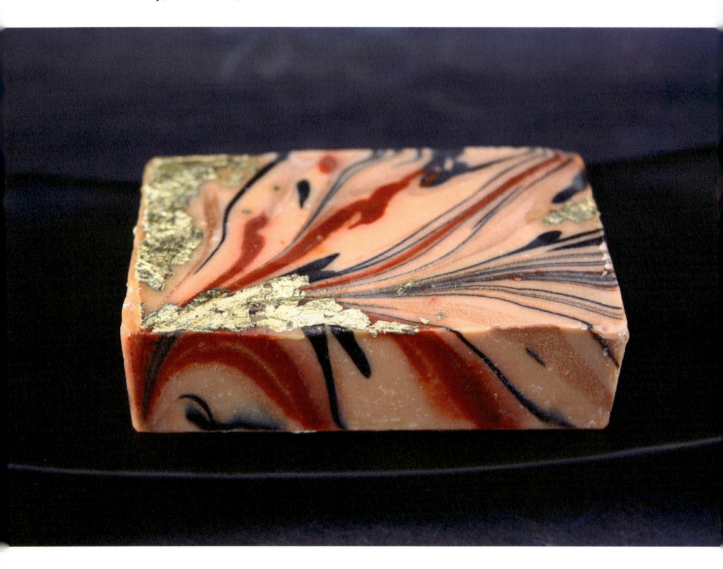

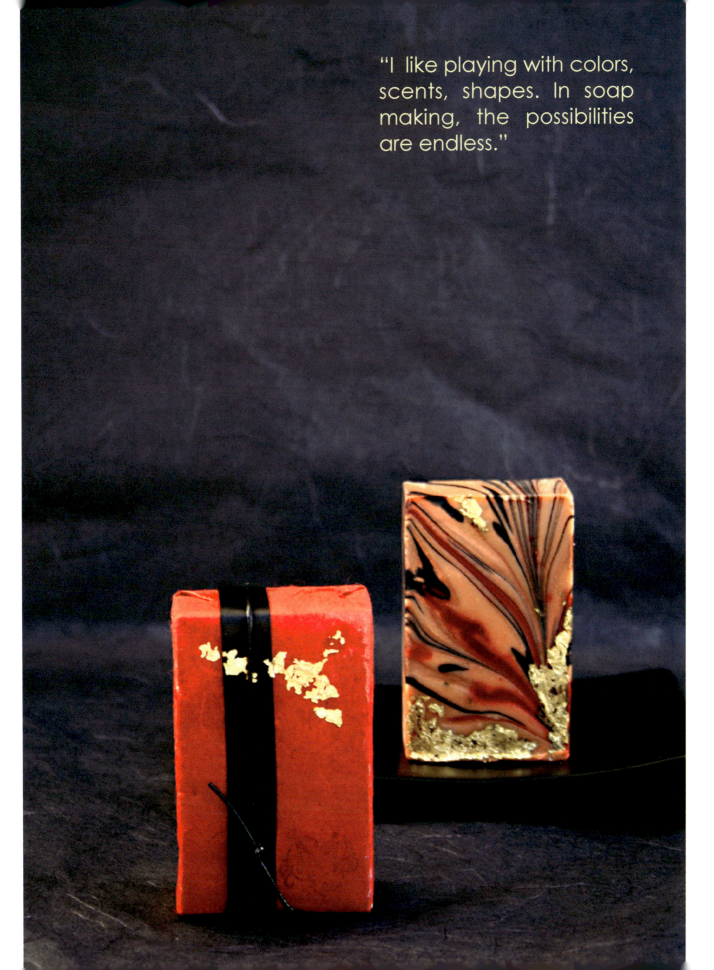

"I like playing with colors, scents, shapes. In soap making, the possibilities are endless."

Inspiration

My name is Karine, I am 33 years old and a happy mother of 3 children. I started to make soap bars 3 years ago. As soon as I put myself to it, it became a real passion. I immediately saw the possibilities and creativity that comes out of it. I studied art and photography which I consider great forms of artistic expression and my soap bars quickly became one of these to me.

There are many things which inspire me and give me ideas. Nature, things around me, cooking ingredients (milk, salt, fruit juice, etcetera), but what inspires me most is painting - especially Pop Art, the Impressionists, and painters such as Gustav Klimt and Jackson Pollock. I like playing with colors, scents, shapes. In soap making, possibilities are endless.

When creating a recipe, I like matching an idea with a fragrance and a color. I'm always searching for the best combination. Like a painter, I try to create something coherent from the beginning to the end, to make a whole even though I surely know that these soap bars are ephemeral and will certainly end in the water of a shower. To me, it is Art.

Inspiration

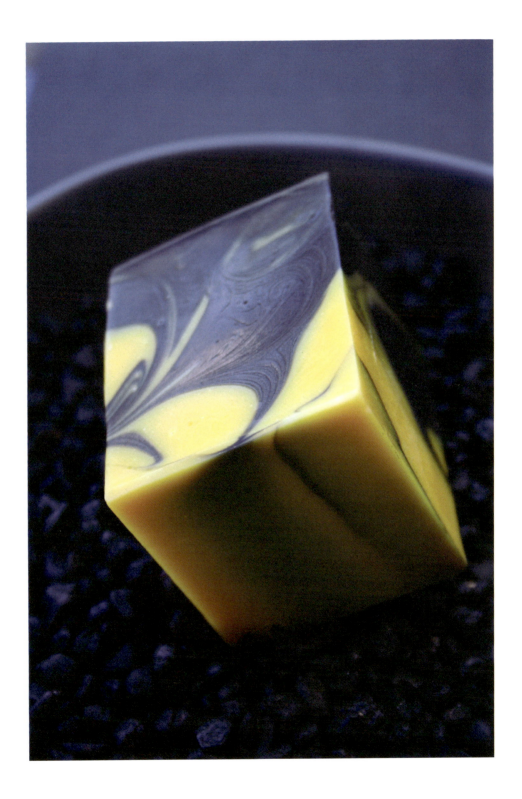

Julie Dutt

Latherati Soap Foundry
Rome, New York, USA

"I want them to feel like they're picking strawberries at Donwell Abbey in Jane Austin's 'Emma'."

Inspiration

Hello, my name is Julie Dutt. I am an Upstate New York-based entrepreneur and the owner and designer of Latherati Soap Foundry; nestled in the foothills of the picturesque Adirondack Mountains. I make handmade cold process soap and other bath and body products - all inspired by books.

For a majority of my life, I've fostered an ever-growing passion for books and classic literature. I've also developed a love for soap making. Latherati is a juxtaposition of these two passions. I often spend my days curled up with a great book or with my hands immersed in indulgent oils.

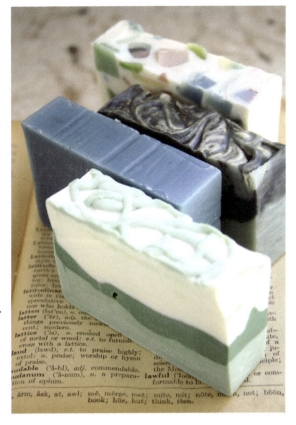

When I read, I constantly contemplate every aspect of the setting, era, and characters. Then, I custom blend my fragrance and essential oils until I believe it truly captures the essence of the book. I love most classic literature but have a special penchant for Jane Austen and Thomas Hardy. The language strikes me as both beautiful and descriptive, and creates a clear vision for the product I'm about to create.

Along with a visual, I can often imagine the scent of a certain setting. That's easy for me when I'm reading about an ocean or a plush English garden, but it's not always that way. It takes a bit of intuition and knowing how various scents blend together.

At the end of the process, I choose colors and other ingredients that compliment the fragrance blend. Ocean scents usually get topped with sea salt; and my chocolate soap uses real cocoa butter. I want them to feel like they're picking strawberries at Donwell Abbey in Jane Austen's, Emma, or toasting a glass of champagne at one of the Great Gatsby's parties.

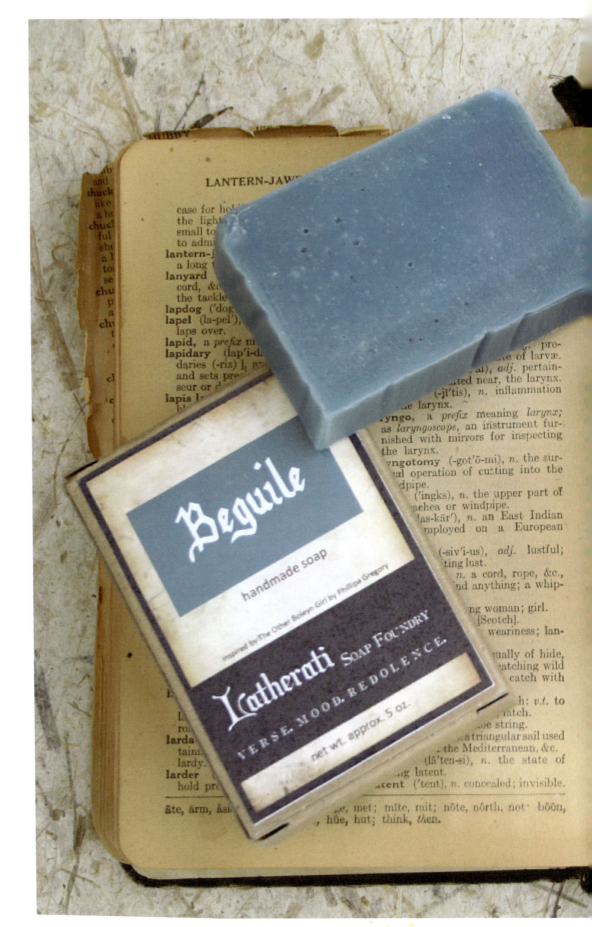

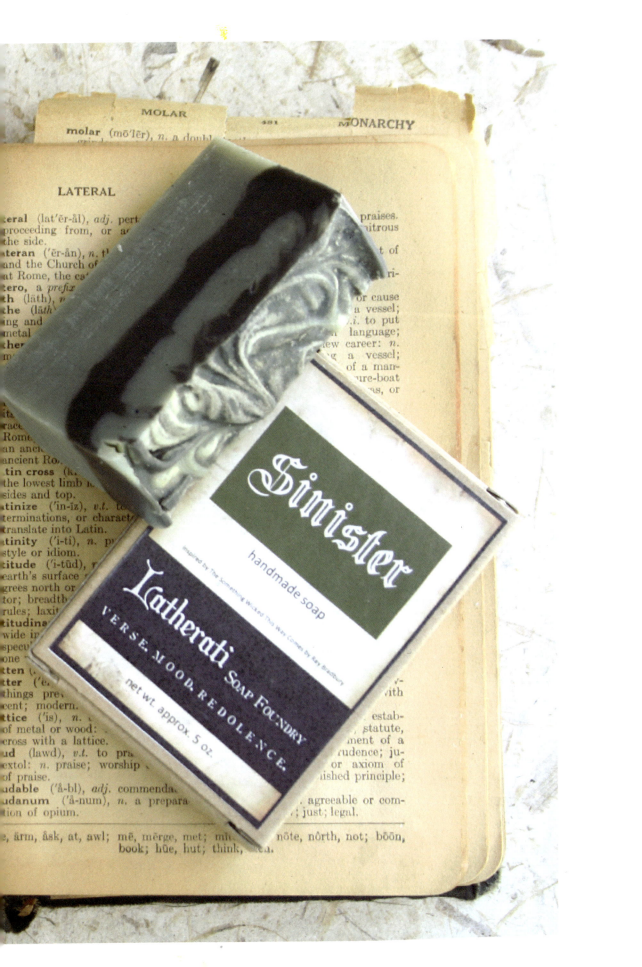

Sara Jezierski

Cleaner Science

Houston, Texas, USA

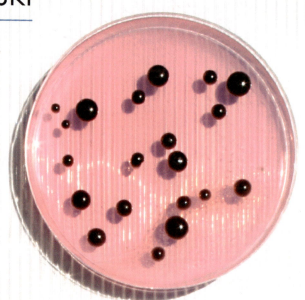

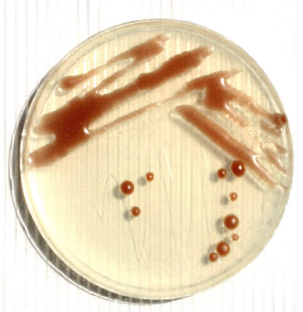

"I thought it would be hilarious to have a soap that looked like the exact thing you're trying to get rid of: germs and bacteria."

Inspiration

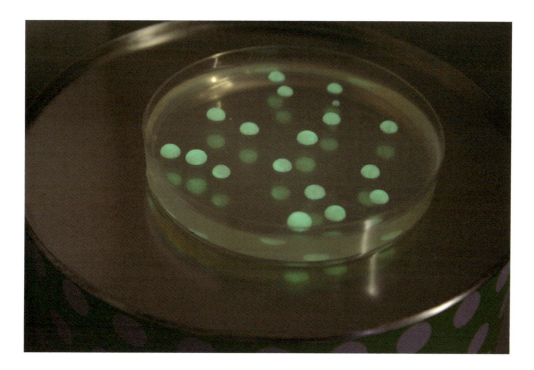

The idea of petri dish soap came about one day while I was studying for classes. I am currently a Pharmacy student, so I was studying when I came up with the idea. I thought it would be hilarious to have a soap that looked like the exact thing you're trying to get rid of: germs and bacteria. It's healthy daily reminder to wash your hands and stay clean! I love that it's also a conversational piece, something that most soaps are incapable of creating.

Working with soap has not only been a new science to learn but also a form of art I was unfamiliar with. The most difficult part of the soap making process is re-creating the various textures of the bacterial colonies growing on the dish. This also adds to the fun of making these soaps! Each is designed after a real species of bacteria. Bacteria can actually be a beautiful, natural art, but it can be hard to re-create.

One of the joys of working with soap instead of real bacteria and petri dishes is that I don't have to worry about spilling actual E. coli, S. aureus or Salmonella all around my workstation. The best benefit of the job is that I have become even cleaner! I must say, however, that it still feels weird packaging petri dishes into little baggies and mailing them all over the world. I'm not quite sure I'll ever get used to that!

I love that soap making is very much a science in itself, and it's such an exciting challenge to try and re-create these pieces of nature's own art.

Regina Panzeca

Soapopotamus

Dallas, Texas, USA

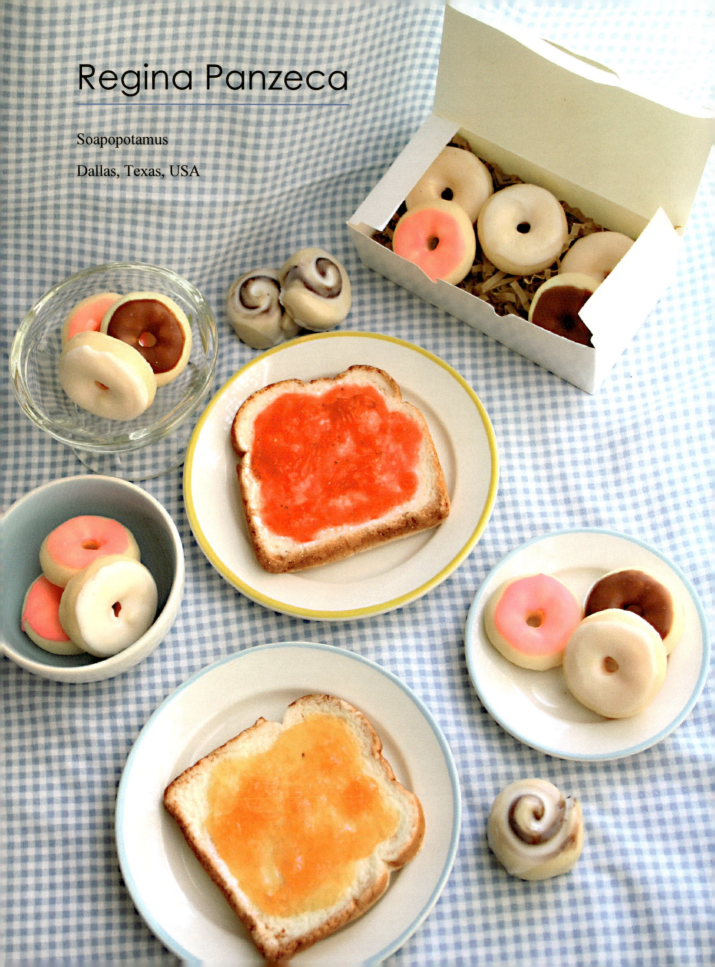

Inspiration

I've always had an odd fascination with making things look like other things - replication is an art form that I return to again and again, using different materials and techniques. I've touched on everything from knitting stuffed animals, sewing dresses that look like hamburgers, tediously crafting realistic flowers out of silk, and eventually, soap happened to me. Thank goodness!

I'm incredibly inspired by my materials so getting familiar with my options, learning various techniques, and building my stock of supplies really sets my creativity free. Now there is more faux food than real food in my kitchen!

Food makes me laugh. It's a truly great source of inspiration. Everyone needs it, we all spend lots of time with it, and there are so many textures, tastes, and aromas. Think about the variables when it comes to food - they are a replicators dream!

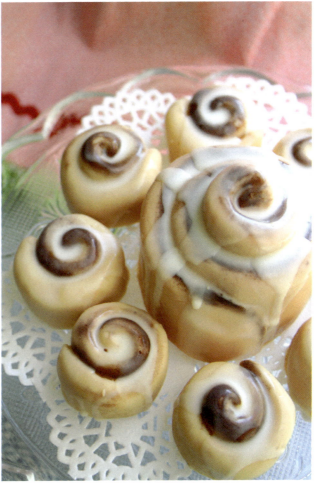

When I set out to make a new food soap, my first step is to break down what set of fragrances to combine to imitate the food's true aroma. Next I decide what kind of molds and shape components to use. Colors, textures, and fine tuning round out the process, and with some trial and error comes a new soapy snack!

I always work best when I have friends or loved ones to keep me company. Since most of the time I'm in the kitchen soaping it up, it's pretty easy to find me. Anybody looking to spend some quality time usually jumps right in to help. My lovely mother can be found cutting up my raw ingredients, my pals will help me pour and package while we have a chat and laugh it up, and sometimes my dad wanders into the kitchen just to hassle me about how it's so unfair that there aren't any real donuts to eat, since I've made the whole house smell just like them!

Inspiration

Inspiration

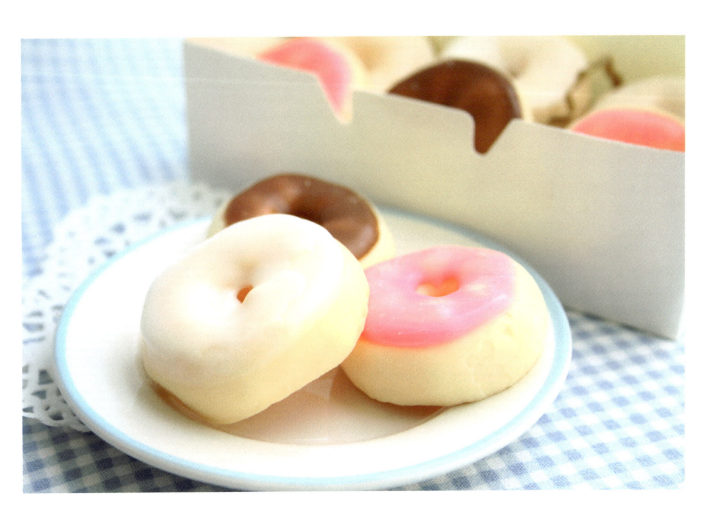

"I've always had an odd fascination with making things look like other things."

Inspiration Artisan Web Sites

Sister Cathleen Marie Timberlake of Monastery Scents

www.monasterycreations.com

Sharon Jenkins of Morgan Street

www.morganstreetsoap.com

Britton Boyd of Haus of Gloi

www.hausofgloi.com

Estermann Karine of Ka Fée

www.kafee.fr

Julie Dutt of Latherati

www.latheratisoap.com

Sara Jezierski of Cleaner Science

www.cleanerscience.com

Regina Panzeca of Soapopatomus

www.soapopotamus.etsy.com

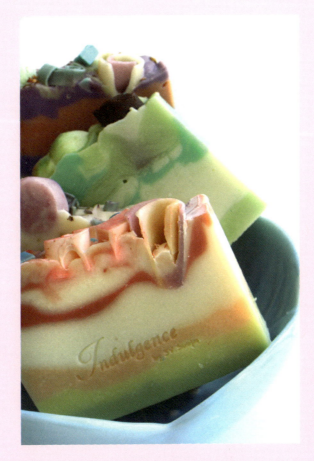

Technique

Thomas Morganstern

Adirondack Aromatherapy

Saratoga County, New York, USA

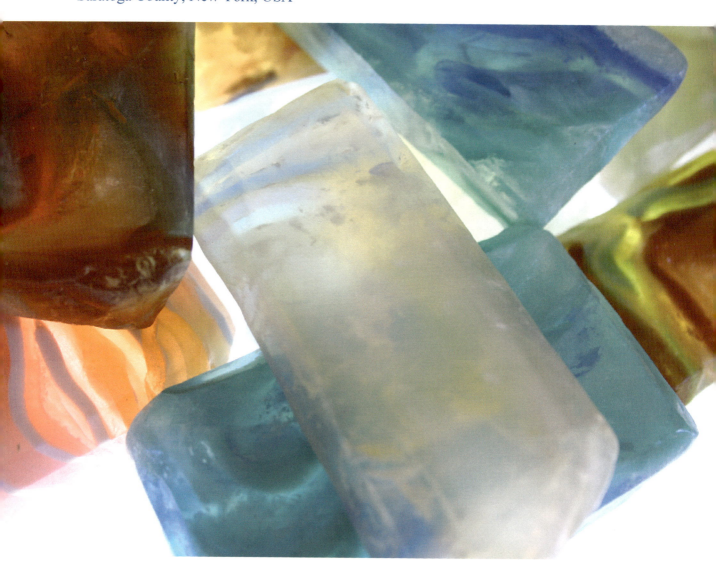

"Working with my wife has been the best experience of my life."

Technique

My love of clear glycerin soap crafting goes back many years. I got my first taste working for a corporation that produces designer soap back in 1995. It was the first time in my life I had ever done creative visual art and before long moved into doing research and development into possible new soap lines. After several years, the corporate scene had really dampened my initial love of the craft and I moved into carpentry for the next 10 years.

Soaping stayed as an occasional hobby and creative outlet but it wasn't until my wife Gretchen decided to start an aromatherapy business that my passion was reignited. The botanical blends used in our soaps are inspired by Gretchen's lifelong love of botanical perfuming and essential oil blending.

Clear glycerin soap has many qualities that make it a unique outlet for expression. It's clarity makes it not only perfect for color, but can also serve as a window into whatever wonders are inside the bar. It engages not only the eyes but the nose, a combination of sensual stimulation that few mediums can deliver, and in a form that has a daily function in life.

Working exclusively with naturally derived essential oils, resins, and absolutes to fragrance our soaps has been challenging and immensely rewarding. The practice of scent blending is an art of transporting an individual to another time & place. The art of the bath is ancient in its associations with physical and spiritual purification. We combine our knowledge, gifts, and talents to tap into both mediums, creating a product that reflects our mutual love for nature.

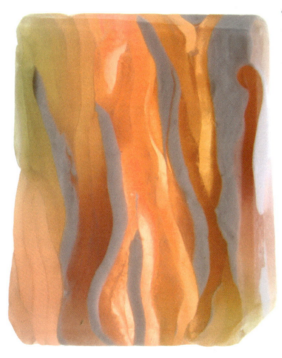

Sometimes the dreamy essential oil blends that Gretchen comes up with inspires the designs of our soaps. Sometimes I get an idea for a color scheme and she will make a blend around that. The aromatic impressions of these soaps is every bit as important as how they look to us, as such I call these 'our soaps'. Working with my wife has been the best experience in my life, the joy of which inspires me to create such beauty as I am able.

Technique

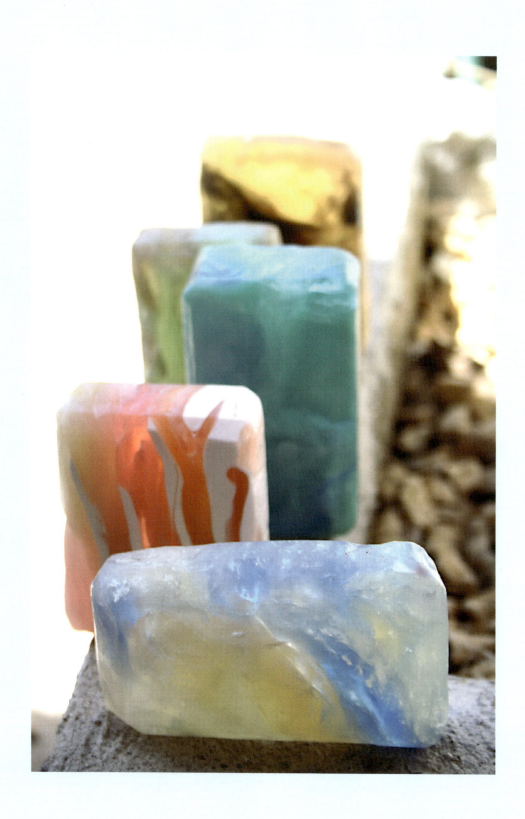

Technique

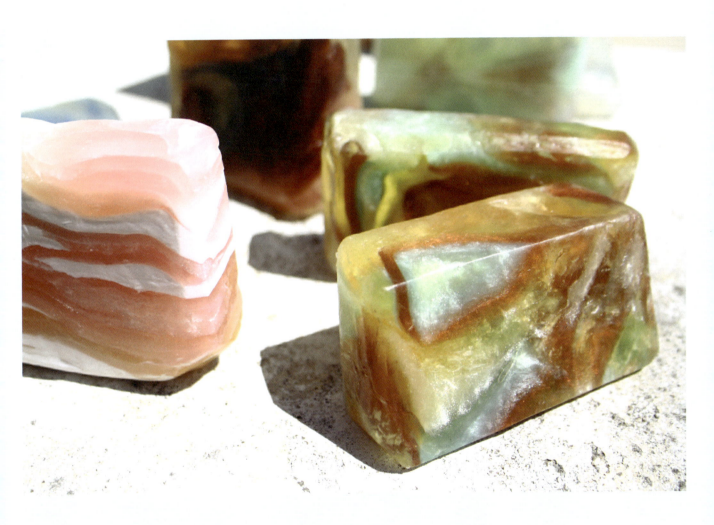

Erin Pikor

Naiad Soap Arts

San Diego, California, USA

"I am obsessed and won't sleep until I am satiated."

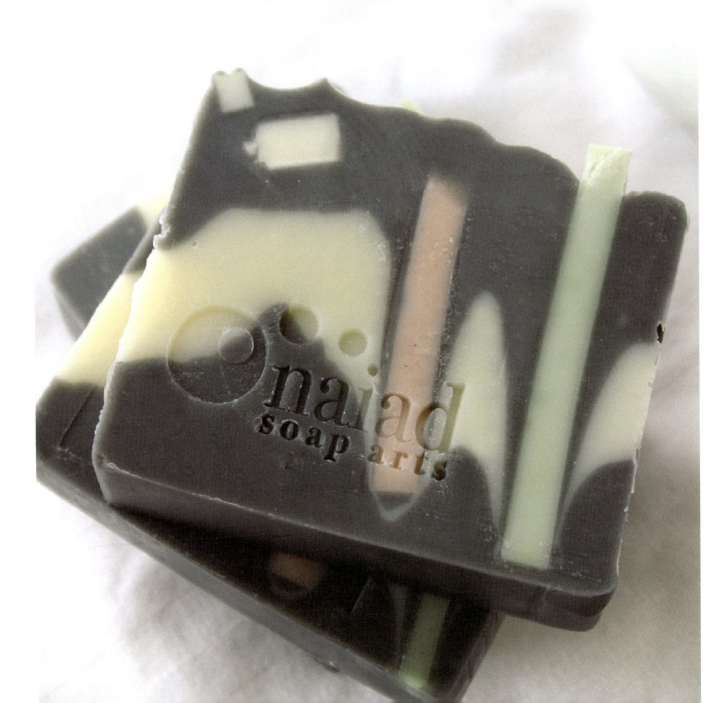

Technique

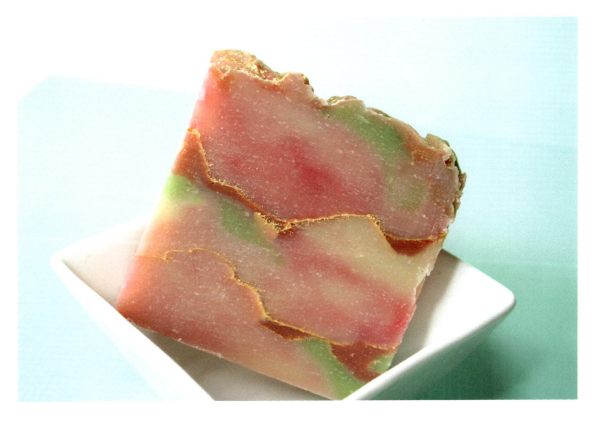

I am looking out a window a few miles above the ground gazing over the Sierra Nevadas and their whipped meringue like peeks, pondering how to get that same texture on top of my soap bars. I am drinking a cup of tea and the cup is a fabulous Frank Lloyd Wright design in overlapping circles and I visualize it in a bar of soap. How would I get that pattern? What colors would I have to blend to match the cup? What tools would I need to get these shapes? I am taking a walk on a cool March morning and the first of the ice plant buds are blooming, an electric magenta against a juicy green backdrop and I go through my mental inventory of fragrances, formulating a perfect scent to pair with these colors in my next batch of soap.

There are so many talented soap makers, and with most of my business online I feel a great need to stay relevant, to keep making new products, to play with texture and color and scent, to carve out my own little niche. When my customers can't pick up the soap to smell it and feel it, visual impact is the most important thing I can offer.

Once I had enough experience (and "soap batch gone bad" heart aches) behind me I perfected my formulations, which allows me now to focus on manipulating the soap. After testing numerous fragrances, colors, and botanicals, how they behave in soap is muscle memory. Now I play with texture and color. What can I

Technique

do to manipulate the soap at any given stage between mixing my ingredients and unmolding it 24 hours later? 24 hour old soap is like soft clay. What have I done with clay? How can I mold and shape this substance to enhance the

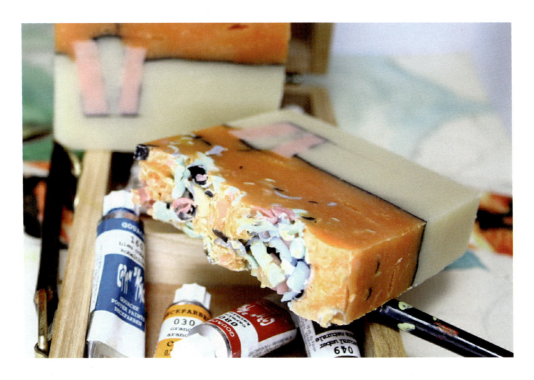

look of my soap? 30 minute old soap is like thick whipped cream or frosting. How can I use that consistency to my advantage in the design of my soap? Can I put it in a pastry bag with cake decorating tips? I can! I can pipe it to look like frosting. I can pipe it into the center of a log of soap to create caverns of color. Can I pipe it to look like rose petals? Now that I have experimented with the myriad techniques, I can look at a flower, a piece of lace, a checkered rug and I know what I have to do to make it into a bar of soap and if I don't know I won't be satisfied until I find out.

What is next? I am walking the botanical gardens and come across an amazing waft of sweet air and my mind goes to work breaking down what I am smelling into workable parts for replication in a batch of soap. I am flipping through a magazine…I am in a bakery filled with pastel confections… I wake up in the middle of the night with a revelation about a process I have been struggling with and I am compelled to test it out right then in a half asleep daze. I am obsessed and won't sleep until I am satiated. I can't help it. I am inspired by everything around me.

Technique

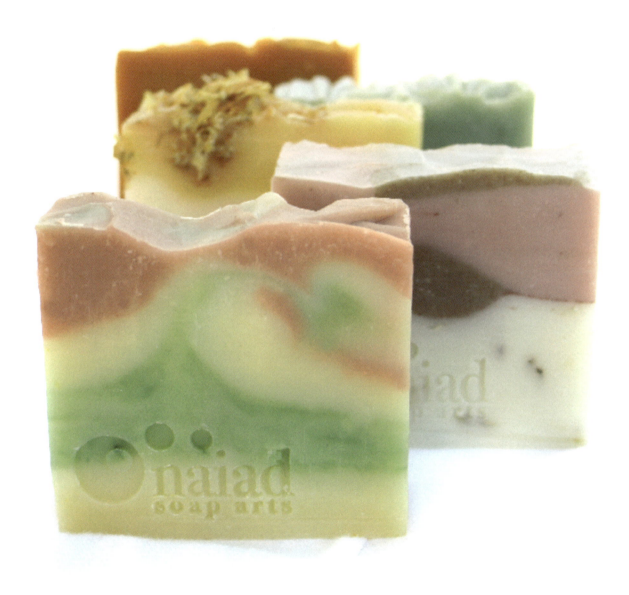

Rebecca Smith

The Abbey James Company

Aurora, Ohio, USA

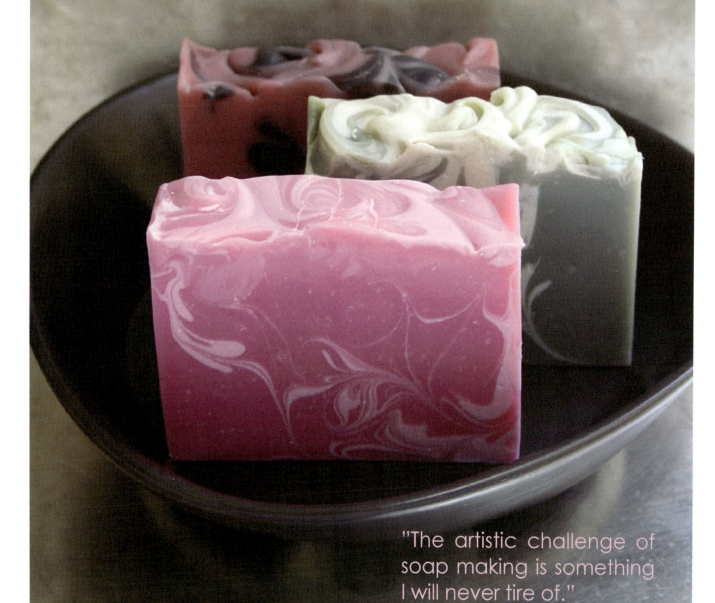

"The artistic challenge of soap making is something I will never tire of."

Technique

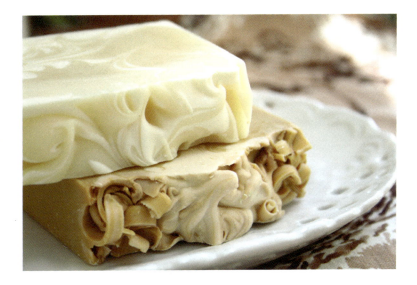

My name is Rebecca Smith, and I am the creator and founder of The Abbey James Co. I live in Aurora, Ohio with my husband and five children.

My journey into the world of handcrafted bath and body products began a few years ago as a search for natural treatments of juvenile rheumatoid arthritis. As I researched the many uses of natural oils, butters, clays and sea salts, I discovered the magical world of handmade soap and so much more.

I have found that creating beautiful soaps and unique packaging allows me to satisfy my artistic nature while producing highly beneficial products as well. Since the onset of my journey, I have become highly aware of the huge amounts of synthetic fillers and possibly harmful ingredients used in so many commercial bath and body products on the market today. Knowing that I am making products from scratch using only the highest quality ingredients gives me great peace of mind in today's chemical-crazed society.

It is the artistic challenge of soap making that is something I will never tire of. I am constantly drawn to new color combinations and immediately want to try them out in soap form. The unveiling of a new loaf of soap can be a beautiful (or not so beautiful) thing. Whatever the outcome, I know it will never be repeated exactly again. Try as I may, it is near impossible to duplicate a bar of swirled soap exactly. However, I'll keep trying! Some of my best soaps have been accidents that I felt certain would end up in the "for family only, never to be seen by the public" bin, only to find that 24 hours later they are absolutely gorgeous. Such is the fun that always keeps me coming back for more!

Technique

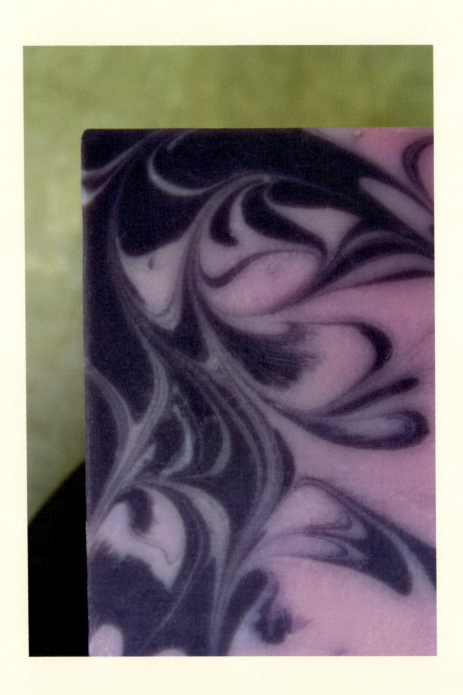

Technique

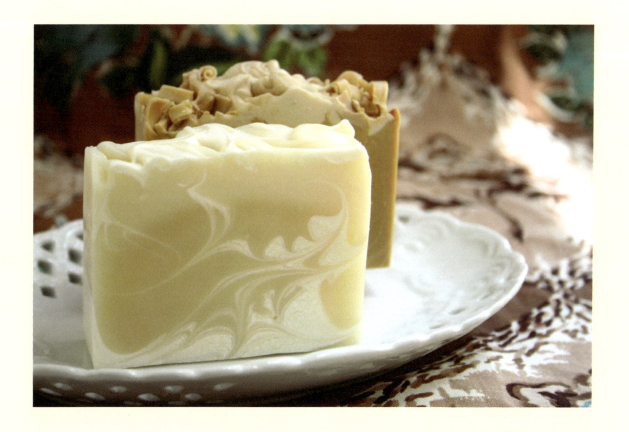

Sherri Al-ahmad

Sherri's Scents and Soys

Scottsdale, Arizona, USA

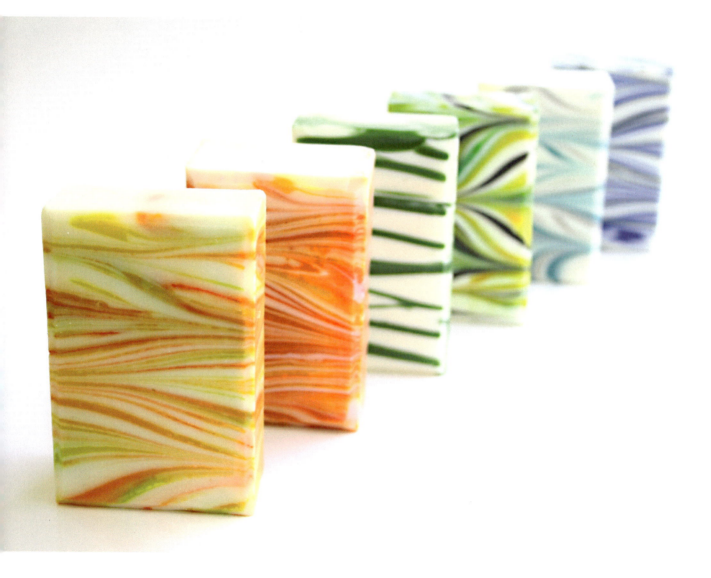

"I am very blessed to be healthy and doing what I love"

Technique

My interest in handmade soap began when I was receiving chemotherapy treatments for Hodgkins Lymphoma and my skin became very sensitive and irritated. My doctor told me that it was most likely an allergic reaction to the detergents and sulfates in my soap. I was amazed to find that most of the commercially made soaps contained many synthetic additives. Since I could not find any natural, healthy and environmentally friendly soaps in the market, I thought I would try to make my own.

I started by searching the Internet, joined soap forums and read as many soap making books as I could find. Suddenly an entirely new world of soap making opened up to me. I began by making glycerin soaps for family, friends, and myself and found that I really enjoyed the artistry and creative process of making soap. Before I knew it I was completely addicted!

Along the way, I discovered the cold process soap making method. At first, I was intimidated by making soap from scratch. I studied the beneficial properties of oils and butters, what each one contributed to a bar of soap, how to formulate a recipe, hot to use the lye calculator, and most importantly the safety precautions when using sodium hydroxide.

Inspiration for my soap always starts with a fabulous fragrance, and then I envision the colors and the swirling technique I am going to use. My swirling continues to be a challenge, but for me it is the best part of soap making and where I get to express my artistic and creative side.

After years of research, testing, and practice, I still feel passionate about making soap. Every new batch is just as exciting to make as the first. I am very blessed to be healthy and doing what I love. I cannot imagine doing anything else.

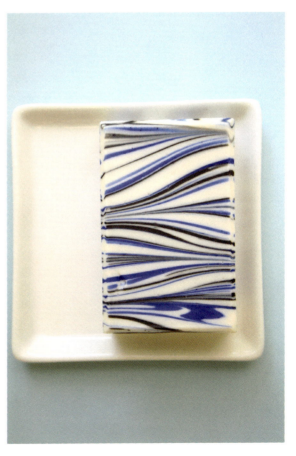

Technique

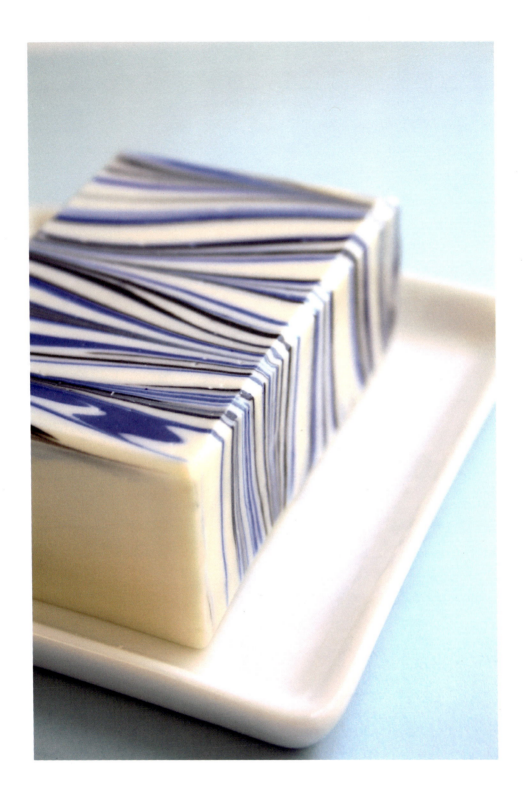

Technique

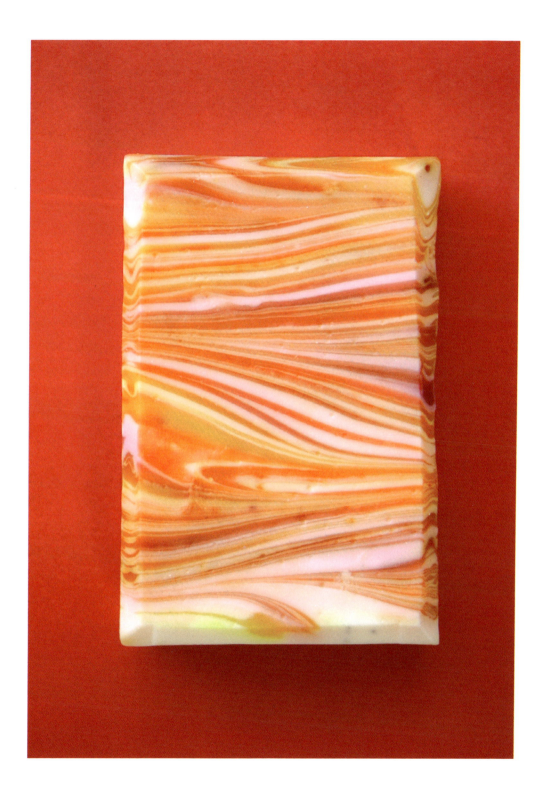

Debbie Chialtas

Soapylove

San Diego, California, United States

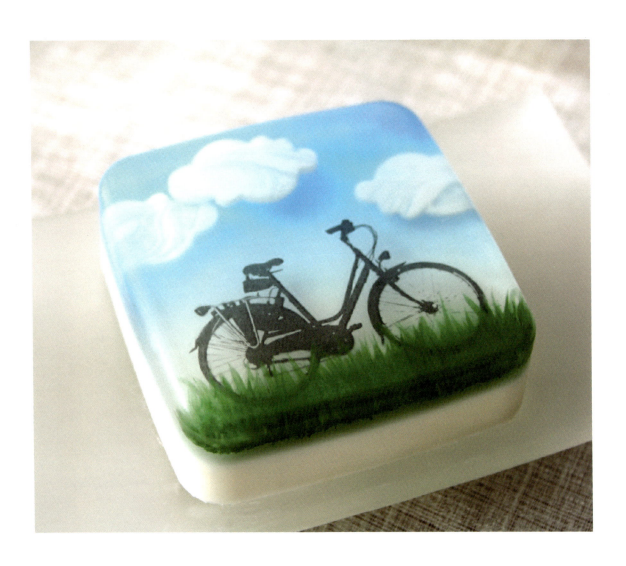

"When I bought my first batch of glycerin soap and started playing around, I felt like a kid again."

When I started making soap I was working in apparel manufacturing. From the time I played with Barbie dolls as a kid I loved fashion design, but the realities of the industry and too much time in the corporate world really hurt my creativity.

So when I bought my first batch of glycerin soap and started playing around, I felt like a kid again. Since I had never been taught how to do it, I just learned by trial and error. It was so liberating not to have any rules to limit my ideas, so they came like a tidal wave!

I was due to have my baby in a few months so I made soap like crazy. At my baby shower I gave soaps away to my friends and family. After my son was born I still wanted to make soap, so I launched my new hobby business: Soapylove.

What inspires me the most about glycerin soap crafting is its potential. There are so many aspects to explore: color, texture, clarity, shape, layering, consistency. It seems like nothing is impossible. Since the craft has been around for quite a while there are many supplies to try and it's always great to just experiment and see what happens.

I also love to design for the fun of it. Most of the new styles I develop are just for my digital magazine called Let's Get Soapy, my book, or for blog posts. I love to see how other people interpret my tutorials for their own style.

Although I have been making soap for almost 5 years there is always something new to try. Fashion, interior design, food bloggers, and other crafts influence my work and give me an endless source of ideas.

Soap has taken me out of corporate world and into the art world. I'm able to spend so much more time with my children than I could ever have hoped for, and I get to spend hours everyday pursuing my passion. I'm so grateful for soap making!

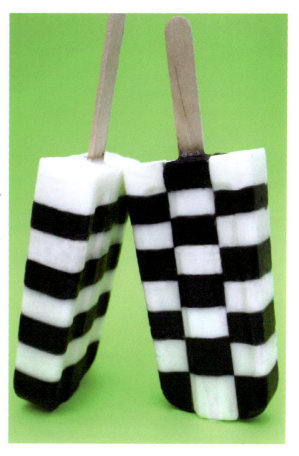

Technique

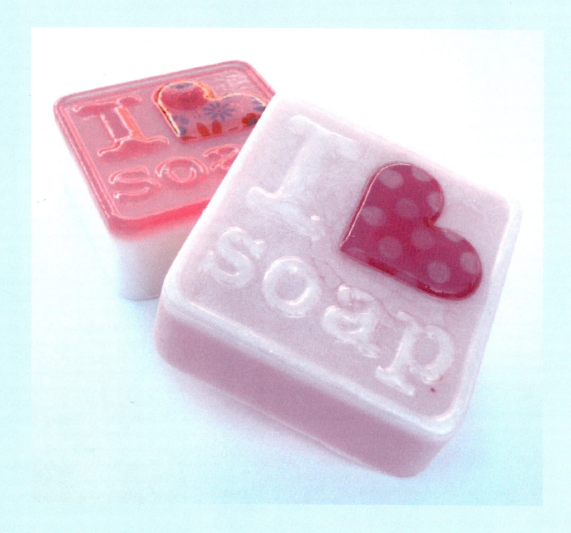

Technique

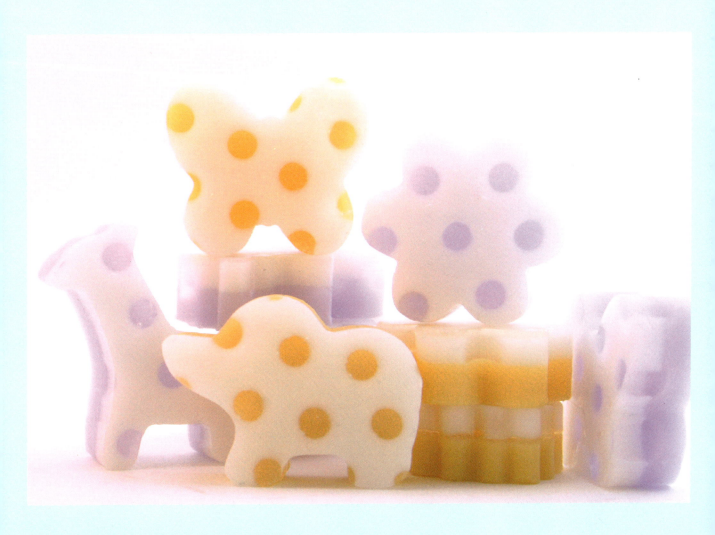

Silvia Victory

Indulgence by SV Soaps

Nampa, Idaho, USA

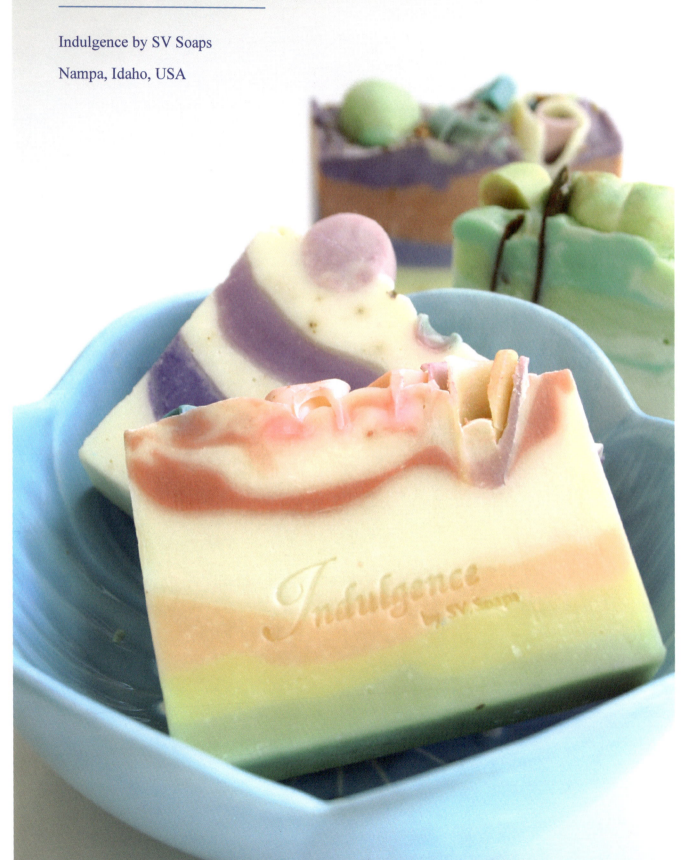

Technique

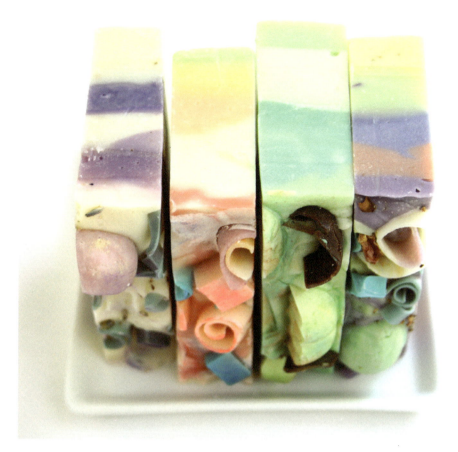

I started dabbling in soap making in 1996 with my mom. We bought every book we could find on natural soap making and started experimenting. From that point on I was hooked. Soap making is definitely my passion . Yes, I admit I am addicted to soap. It is so satisfying to make something that is good for your skin, the environment, and has a bit of artistic flair.

I love to put a lot of creativity into each batch I make. I constantly get asked what inspires my soap designs. I get inspiration from everything, but mostly from my love of baking and painting. I try to combine both passions into fun and fabulous looking soaps.

I am always striving to learn new techniques and come up with fun designs. I have so many notebooks and scraps of paper with soap drawings on them. One might wonder how many pictures of soap one person could draw, well I must tell you it is a lot. My 5 year old son even draws pictures of soap now and tapes his work to my studio walls.

Technique

"I get inspiration from everything, but mostly from my love of baking and painting."

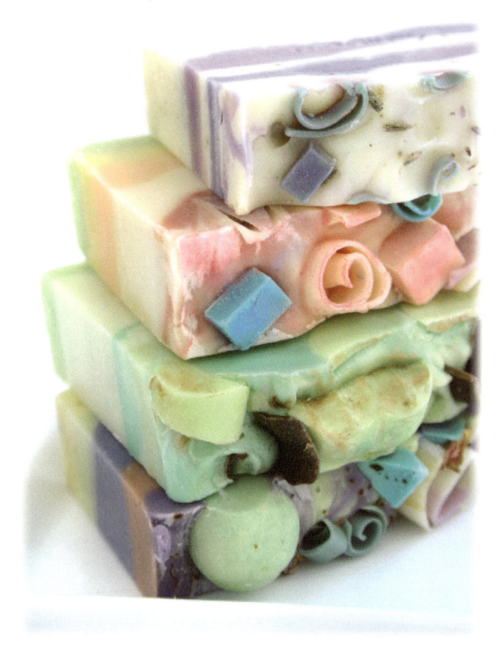

Technique

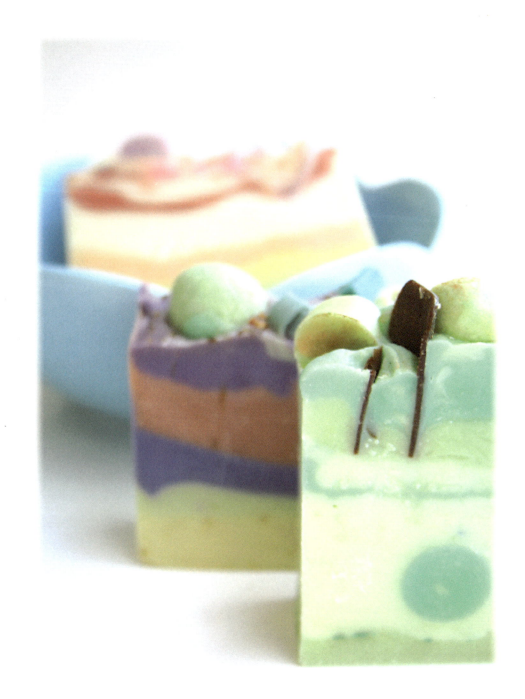

Technique Artisan Web Sites

Thomas Morganstern of

Adirondack Aromatherapy

www.adkaromatherapy.com

Erin Pikor of Naiad Soap Arts

www.naiadsoaparts.com

Rebecca Smith of

The Abbey James Company

www.abbeyjames.etsy.com

Sherri Al-ahmad of

Sherri's Scents and Soys

www.sherrisscentsandsoys.com

Debbie Chialtas of Soapylove

www.soapylove.com

Silvia Victory of

Indulgence by SV Soaps

www.svsoaps.com

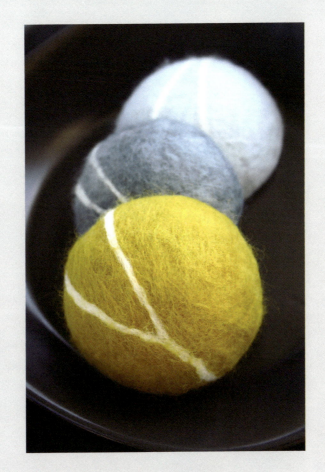

Presentation

Allison Hill

Epically Epic Soap

Chicago, Illinois, USA

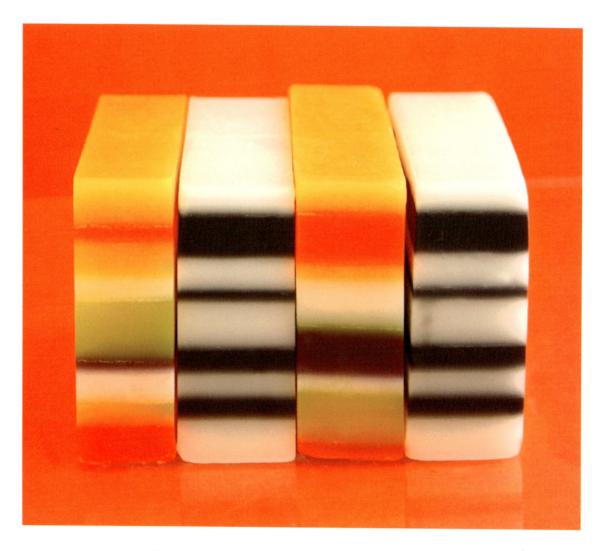

"Ideas come to me from a personal story, bits of pop culture, and sometimes my favorite desserts."

Presentation

How did soap come to me? I enjoy natural cosmetics and aromatherapy. I hoard and collect bottles of cream, soaps, and perfumes. If you get know me you will see that I almost never wear makeup or get an expensive hair cut. I'd rather spend my money on soap.

A year and a half ago I decided to start a little adventure. I told myself "let's see if I can make some decent soaps, and if they turn out okay I can give them to my friends as Christmas presents." I went online for hours every day studying soap making and watching videos to learn the basics. I thought that everything I needed to learn was there, but it was hours of tears and frustration that actually completed my learning process as a soap maker. After a lot of practice and mistakes I was finally happy with the results.

I showed the soaps to my family and friends and they gave me lots of encouragement, so I decided to take it seriously. I became completely obsessed. I worked on new soap ideas and techniques day and night. I remember riding my bike all around the city looking for the right essential oils, molds, and supplies. I created a line of soaps with colors and forms that relate to their names and scents such as Mrs. Zebra, Mr. Stripey, and Lovely Tulip. I designed Lovely Tulip at first for my mom, who always plants her favorite red and yellow tulips in the yard.

I like how soap making is an art for several senses. To me the visual appearance is just as important as the scent and feel of the lather. I start to design a soap like I am sketching a painting. Ideas come to me from a personal story, bits of pop culture, and sometimes my favorite desserts. I make a little drawing of the design I have in mind, select the right colors and at the end mix the scent.

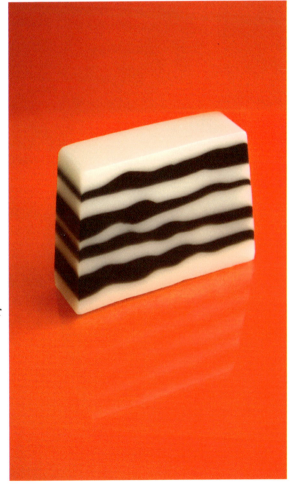

Presentation

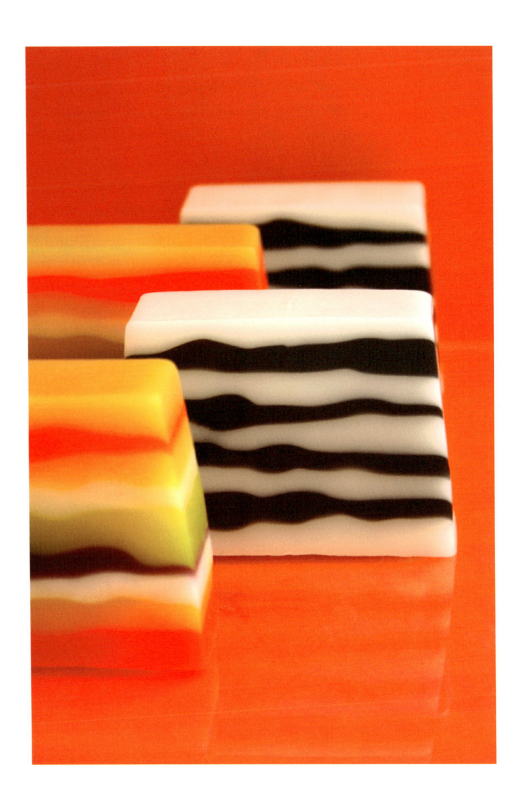

Presentation

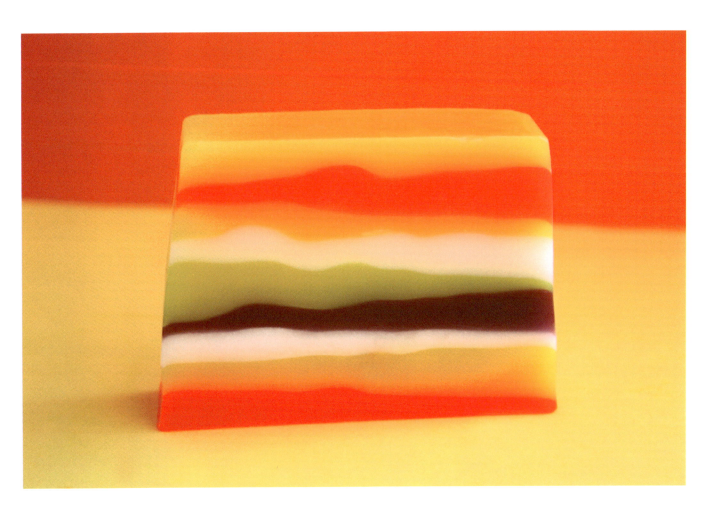

Cordelia J. Smith

Sweet Petula

Seattle, Washington, USA

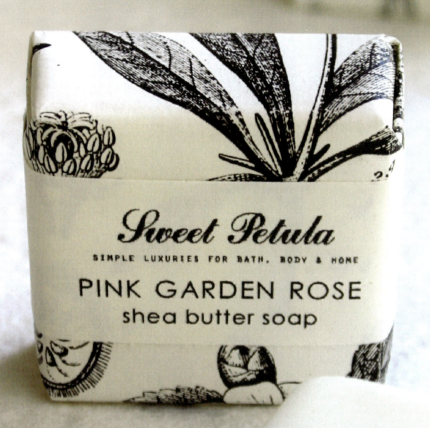

"I'm obsessed with blends and finding just the right mix."

Presentation

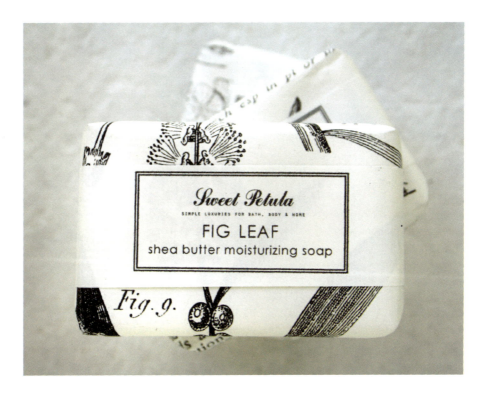

The products I make are all about indulging your senses. My goal has always been to make an amazing product that works wonders on your skin, but also looks really pretty in your bathroom just begging to be used. I strive to create items that smell fantastic, but also look fantastic.

When I started my company in 1996, I wanted to make pure vegetable products but there were no soap making books available to me. I had to learn from experience. There were countless batches of failed recipes, tons of wasted materials and even tears! Eventually, I created an olive oil recipe that has remained my mainstay. Once people use my soap they rarely go back to other kinds.

Interestingly enough, about 5 years after I started my business I learned that my great-grandmother also made soap. I found her hand bound and handwritten recipe book tucked into a cookbook.

One of the best parts of my job are all the varied tasks I get to do in one day, and I go through different phases of what I focus on the most. A few years ago it was packaging. This year it is fragrance.

I'm obsessed with blends and finding just the right mix. Lately everywhere I go inspires me to create a new fragrance. I've even been dreaming in scent! I think in my next life I will be a perfumer.

Zoe Djukic

SoFino

Charlotte, North Carolina, USA

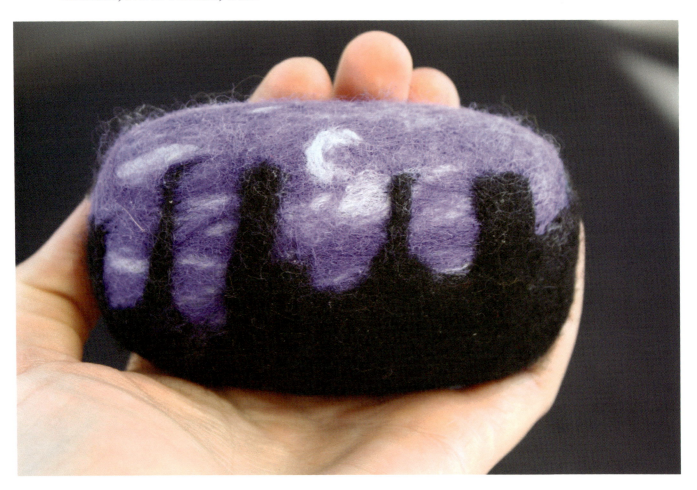

"I approach the work as a kind of game and let inspiration guide me through the process."

Presentation

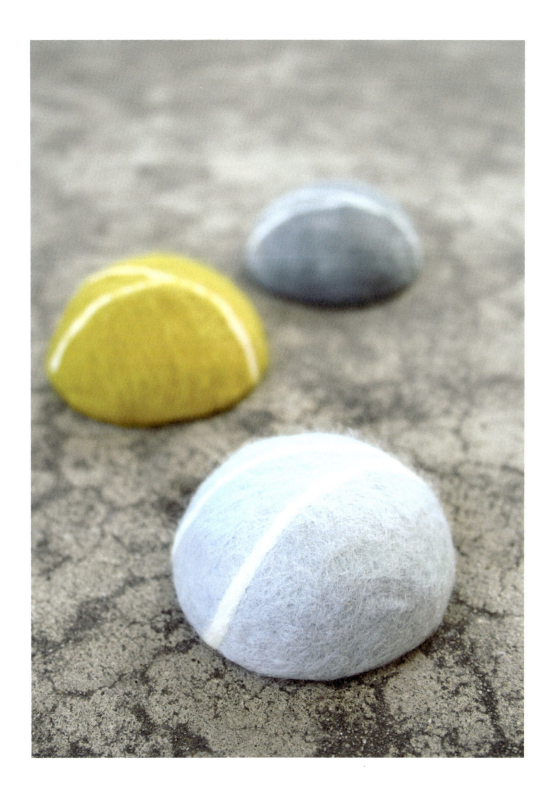

Presentation

I was born and raised in Belgrade, Serbia. Growing up in a time of war, my friends and I had to be very creative to entertain ourselves. This meant using everything around us, and nature has always given me inspiration because it is everywhere. This connection to nature made it much more tolerable to get through a difficult time of war and NATO bombing. I currently live in the Charlotte where nature continues to inspire me in the backyard, in the park, or at the beach.

SoFino felted soaps are the result of my need to take my felting work, which has mostly been with jewelry, in another direction towards different media using nature and my imagination as a guide. This includes getting in touch with another one of my five senses: smell. Soft wool and decorative designs take on another felting dimension with scent. The outcome is a product that is not only aesthetically and sensuously pleasing, but practical.

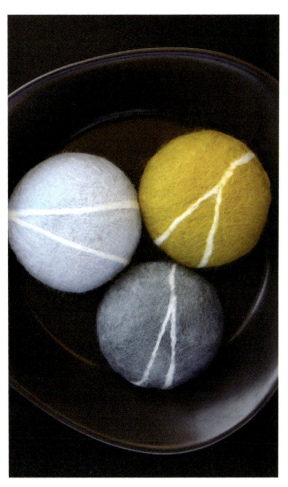

The process itself is a positive experience that I enjoy during every phase, from selecting the scent for the soap and the shape of the soap to the selection of the wool and that detail work. I approach the work as a kind of game and let inspiration guide me through the process. Often, I am inspired by something around me at a particular point in time and that particular piece takes on a different personality than initially intended. Though this process can be more time consuming, it also produces unique results that set apart one felted soap from another.

I always try to put a piece of myself in my work and I think that comes out in my felted soaps. They are unique and truly a snapshot of a point of time in my life because inspiration forms each one.

Presentation

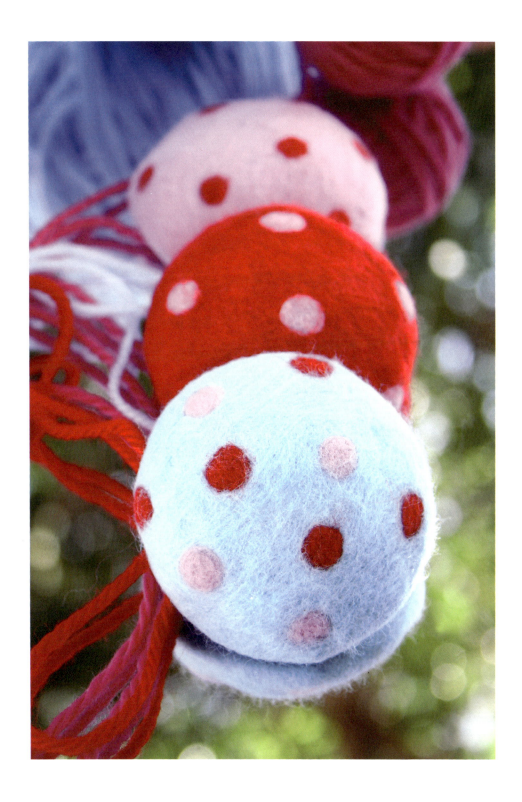

Elea Lutz

Nostalgia Organics

Scottsdale, Arizona, USA

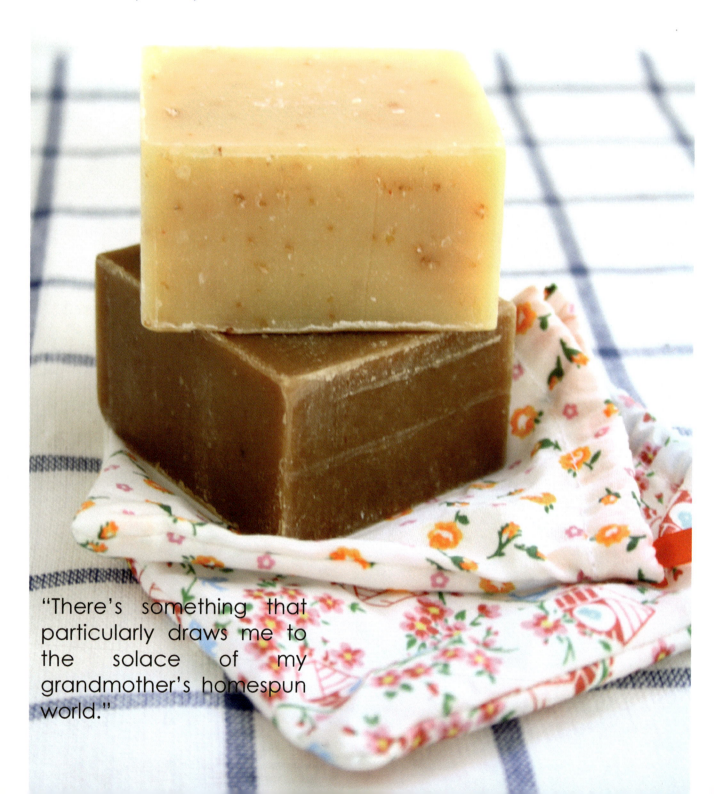

"There's something that particularly draws me to the solace of my grandmother's homespun world."

Presentation

I find comfort in connecting with the past. Like churning soap with an antique wooden spoon or curled up with a sketch pad drawing colorful roses from my childhood home. There's something that particularly draws me to the solace of my grandmother's homespun world. The joy in which she'd fancy a quilt from fabric scraps or set the table with sprigs of aromatic lavender.

My grandmother's home was full of fragrances, sensations and simplicities of yesteryear that I find deeply inspiring. Recipes started in the garden and gifts were always lovingly handmade and dressed with charming details. Sharing these old-world ideas and pleasures with my own family eventually led to what is now my organic soaps and toiletries company, Nostalgia.

Weaving in and out of the Nostalgia collection are many elements cherished from the past. For example, I try to create soap rich with nutrients and aromas while keeping a simple and wholesome ingredient list. In my grandmother's day, sugar was sugar and butter was simply that – butter. There were no unrecognizable ingredients on grandmother's recipe cards. The packaging and presentation – like with grandmother's gifts – are as important to me as the soap inside. I enjoy spending countless hours drawing illustrations for the fabrics and papers that house the soaps or sifting through troves of ribbon to find the perfect one to finish a package. The completed product, I hope, is ripe with thoughtful details that send a flood of sunny sentiments to its recipient.

At the end of the day, my artistic and company goals are one and the same: to create from the heart and offer joyful gifts that are memorable and meaningful. These are the most important ideas inspired by my grandmother. The result, I hope, is a genuine collection of tenderness and originality that blends essences of yesteryear into wondrous pleasures in the washroom and beyond.

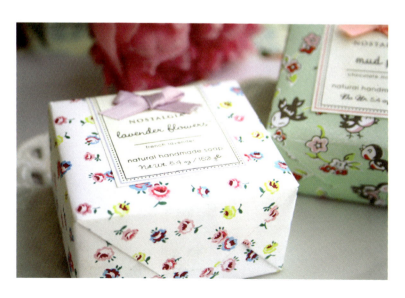

Presentation

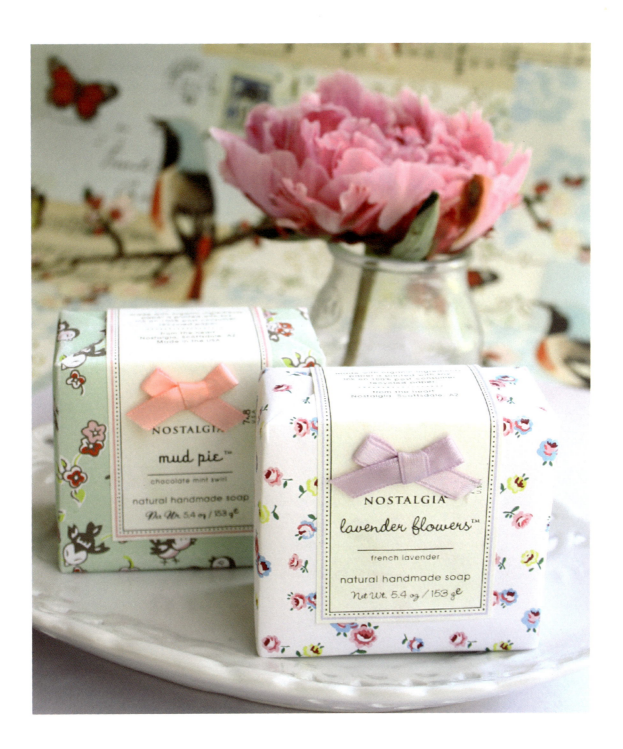

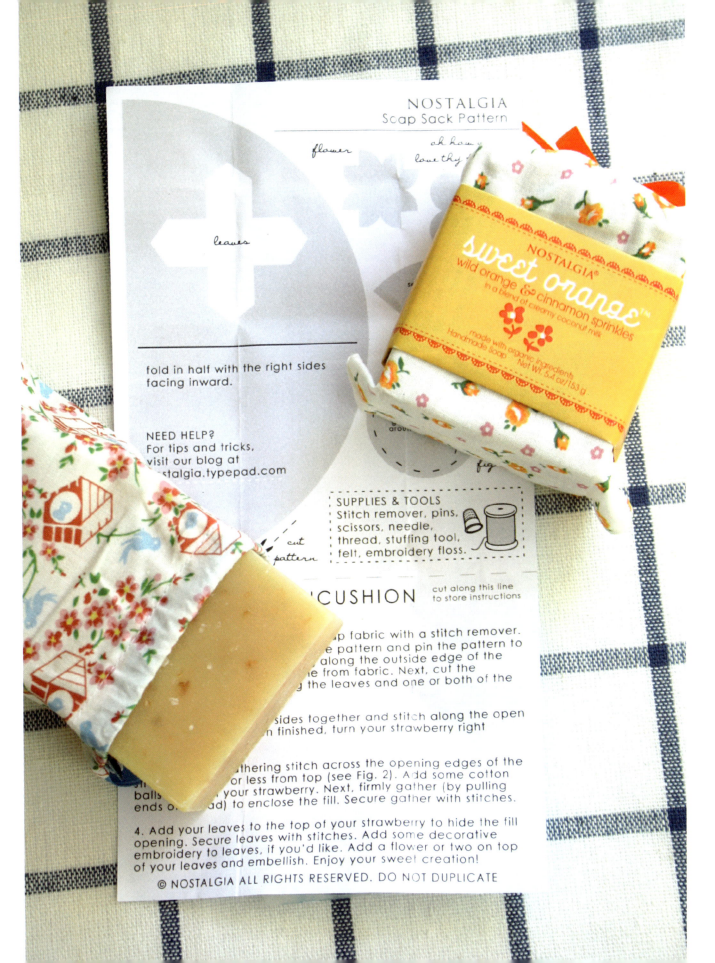

Pamela Vaughn & Tara M. Vaughn

Persnickety Pelican

San Diego, California, United States

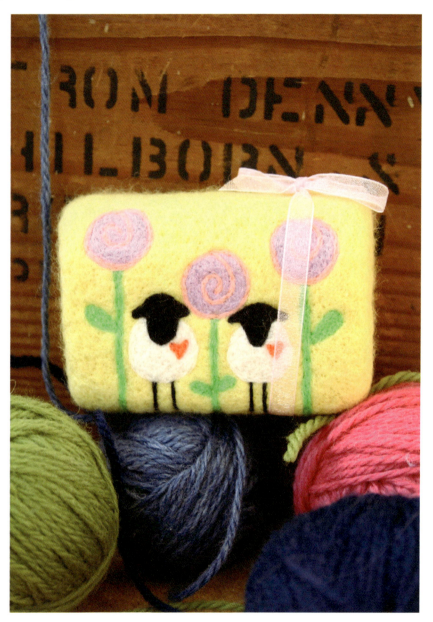

"Thousands of needle pokes later, a cute whimsical felted soap appears."

Presentation

We are a mother and daughter crafty duo that has always had a passion for creating things with our hands. A few years ago, we were trying to come up with a gift to give to our family and friends so we searched for some new ideas. Once we saw the needle felting process we knew we had to give it a try. We started out creating three-dimensional figures like dogs, sheep, and flowers. These were a big hit and we enjoyed coming up with new designs.

One Christmas, we wanted to make some unique stocking stuffers and thought our needle felting creativity could be put to good use. We saw some felted soaps online and thought this would be a perfect gift to create. We only found soaps made using the wet felting technique and we wanted to do much more intricate designs which could only be done using a felting needle.

After the first soap we were hooked! Ideas came gushing out of our heads, into our hands, and onto the soaps. We think of a theme first and create the design as we go. No templates are used, and we don't draw up a design first. The tedious process begins with fluffing and carding the wool roving and applying the base color with a multi-needle felting tool which in itself can take a long time. We love picking through the box of wonderfully bright colored wool and choosing the colors for our design. Then we use a single felting needle and start pushing the wool into the soap. Thousands of needle pokes later, a cute whimsical felted soap appears.

The best thing about our felted soaps is that they can be displayed as a work of art, or used in the bath and shower every day. We get great pleasure out of knowing that our soaps add a little ray of sunshine to everyday life.

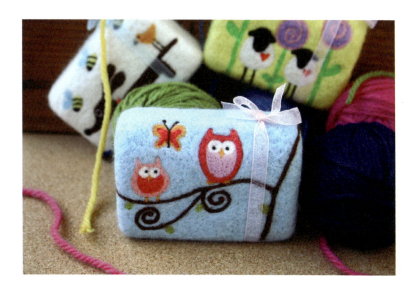

Presentation

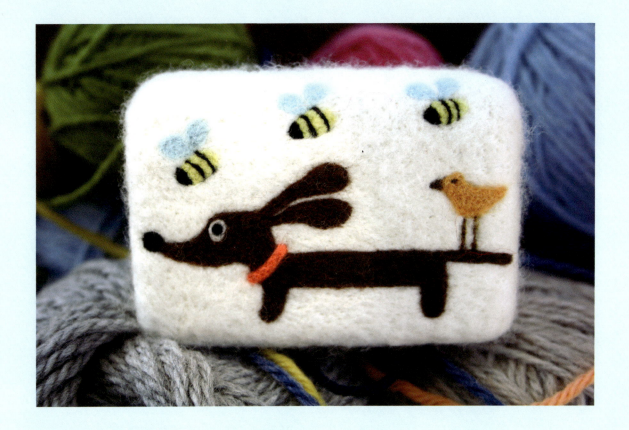

Presentation

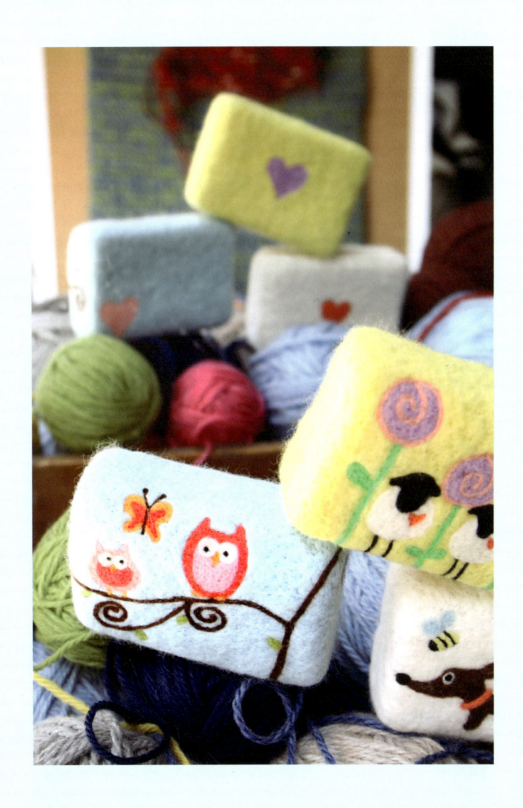

Presentation Artisan Web Sites

Allison Hill of

Epically Epic Soap

www.epicallyepicsoap.etsy.com

Cordelia J. Smith of Sweet Petula

www.sweetpetula.com

Zoe Djukic of SoFino

www.sofino.etsy.com

Elea Lutz of Nostalgia Organics

www.nostalgiaorganics.com

Pamela Vaughn

and Tara M. Vaughn of

Persnickety Pelican

www.persnicketypelican.etsy.com

In closing...

I hope you have enjoyed The Art of Soap! This is just a tiny sampling of the amazingly talented soap makers world wide. In the United States alone it is estimated that there are over 13,000 independent soap makers, and I bet there are many more.

As a soap maker I thoroughly enjoy being part of a passionate and supportive community which freely shares techniques and tips, encouraging each other to enjoy the thrill of soaping success. As a consumer I find it very gratifying to use a product that has been lovingly made by hand, in a kitchen or small studio, and support a fellow soap maker's passion.

If you would like to explore the art of soap making yourself, there are many wonderful books available with recipes and projects. Check your local book store, favorite online soap supply business, or major book retailer such as Amazon.com. For those who would like to enjoy more "soap porn" (see - I told you soap makers are passionate!), here are some of my favorite sites and blogs:

www.thesoapbar.blogspot.com (USA)

www.einfachseife.blogspot.com (Germany)

www.jabon-soap.blogspot.com (Spain)

www.thatsoapsite.com

And my ultimate favorite: http://www.flickr.com/groups/soapgroup/ which is an online soap photo album with over 1200 contributors.

It's hard to make a list because it could literally go on for pages and pages. The fun is discovering them on your own and finding your own soapy style.

Thanks again for taking the time to read The Art of Soap. Your support is helping me pursue my passion, too! For that I'm very grateful. Take care!

-Debbie Chialtas

Editor, The Art of Soap

Owner of Soapylove.com

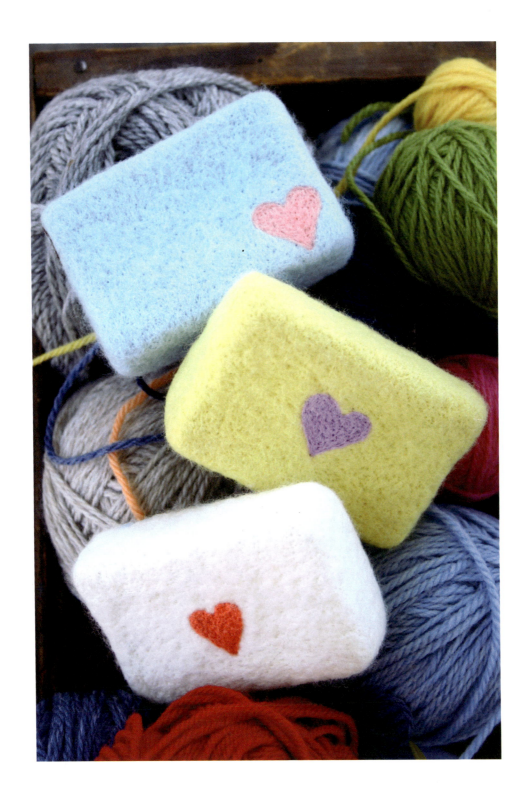

LaVergne, TN USA
15 October 2010
200738LV00002BB